CONTENTS

Study Guide

Bernard Schultz

West Virginia University

History of Art

Revised Fifth Edition

H.W. Janson

Anthony F. Janson

PRENTICE HALL, Upper Saddle River, New Jersey 07458

© 1998 by PRENTICE-HALL, INC.
Simon & Schuster / A Viacom Company
Upper Saddle River, New Jersey 07458

Cover art: The Boucicaut Master (French). *The Story of Adam and Eve,* detail. From Giovanni Boccaccio, *Des cas de nobles hommes et femmes (The Fates of Illustrious Men and Women).* c. 1415. Gold leaf gold paint, and tempera on vellum, 16 3/4 x 11 1/2" (42.5 x 29.3 cm). The J. Paul Getty Museum, Malibu, California.

ISBN 0-13-888447-1
Printed in the United States of America

Part Four: The Modern World

Preface

Among the many values which a work of art possesses is its ability to link the past with the present. Art allows for communication through time and history. As this communication spans across diverse cultures, the study of Art History is uniquely suited to meet the contemporary needs and challenges of multicultural education and, with continuing revelations from new scholarship, to address critical thinking in the classroom.

The study of Art History, however, is both considerable and complex. In 1962, H.W. Janson's *HISTORY OF ART* revolutionized the discipline; that edition, and each successive one, introduced generations of students to the enriching experience of art. The fifth edition revised presents us with significant changes in the text. With the investment of current scholarship and additional material throughout the book, this edition of the *HISTORY OF ART* is well prepared to engage today's students.

To assist you in your studies, each chapter and section in the *HISTORY OF ART* has a corresponding unit in this *STUDY GUIDE*. In addition, the *STUDY GUIDE* is keyed to the Janson text with page and illustration references, allowing for an easy correspondence as you work from one text to the other. Each chapter opens with a brief paragraph which is intended to make you feel familiar and comfortable with the questions which follow. Questions in the *STUDY GUIDE* are of various types; chapter questions, which usually require short essay answers, will guide your comprehension and reinforce your knowledge of the meanings and values of art through history. Your attention will be focused not only on the facts, but also on synthesizing broader concepts which make our understanding of art so meaningful.

As you come to the end of each of the four major divisions in the *HISTORY OF ART* (i.e., The Ancient World, The Middle Ages, The Renaissance Through The Rococo, and The Modern World), self-review questions will allow you to test your skills in new ways. These questions also will introduce you to artistic relationships among various cultures. And, with the presentation of works of art not illustrated in Janson's text, we shall more finely tune your visual and intellectual reasoning.

This edition of the *STUDY GUIDE* utilizes illustrations; some will be familiar to you from the *HISTORY OF ART*, others, as said above, will not. The integration of illustrations with specific questions to direct your approach will strengthen your response to the visual conditions of art in the world.

Always remember that learning the visual language of art and being receptive to art as the communication of a cultural experience require our active participation. To this end, the questions, diagrams, and illustrations are presented in such a way as to encourage a continuing dialogue between yourself and works of art.

Many colleagues assisted me in the preparation of this *STUDY GUIDE*. I extend my gratitude to Marian Hollinger, Kristina Olson, Margaret Rajam, Janet Snyder, David G. Wilkins, and my wife, Mary Louise Soldo Schultz, for many informed discussions on Art History. Eve Faulkes designed this *STUDY GUIDE*, while Lana Gemas typed the manuscript, and coordinated various aspects of the project.

And, it was a pleasure to work, once again, with the consummate professionals at Prentice Hall, Inc., especially Norwell "Bud" Therien, Jr.

Bernard Schultz
West Virginia University

Introduction

Janson, pp. 16-43

Definitions of art and the artist have changed through time and history. In our time, notions of what constitute the "pure" arts, applied arts, and crafts are related to past traditions, from which our modern definitions have evolved. But while we confront immediate difficulties in attempting to answer the question "what is art?" we can establish a set of underlying assumptions to guide our initial understanding. The following questions, which require short essay answers, will assist us toward this understanding.

Art and the Artist

1. What is meant by the definition of a work of art as an *aesthetic object*?

2. What is the role of human imagination in creating art?

3. Why are *shamans* believed to have been the first artists?

4. Why and how are *originality* and *tradition* key factors in evaluating art?

5. Discuss the similarities and differences between these groups of human activities (keeping in mind that these definitions are relative and have changed through history):

 a. fine art–

 b. applied art–

6. How is the concept of taste involved in assessing quality in art?

7. How do meaning (iconography) and style (formal qualities) contribute to the communicative value of a work of art?

1

Today, especially with electronic media such as television, we are constantly beset with a variety of often rapidly changing visual images. We have become accustomed merely to see, without fully looking with a view toward understanding. Comprehending the visual language of art may at first seem difficult to us, for it is like learning a foreign language. It is only by understanding the visual elements of art that we can become active participants in a dialogue with art. Using both Janson's text and glossary as necessary, provide short definitions for the following terms:

medium

line

"graphic art"

color

glazes

light (radiant and reflected)

chiaroscuro

foreshorten

composition

one-point perspective (linear or scientific perspective)

form

relief sculpture

 a. low (*bas*)

 b. middle (*mezzo*)

 c. high (*alto*)

free-standing sculpture

modeling (additive process)

carving (subtractive process)

2. One of the key elements of the visual arts is space; how would you characterize the use of illusory or real space in the different art forms of painting, sculpture, and architecture?

3. Comparison (on this and the following page)

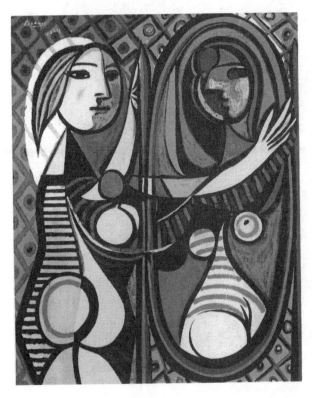

PABLO PICASSO. *GIRL BEFORE A MIRROR.*
March, 1932. Oil on canvas, 64 x 51 1/4."
Collection, The Museum of Modern Art, New York.
Gift of Mrs. Simon Guggenheim.
(Janson, p. 29, ill. 11)

Utilizing what you have learned about the visual elements of art from your reading and the above definitions, compare and contrast these two paintings.

What visual, or formal, elements are similar to each; which are particular to the Picasso and the Vermeer?

3

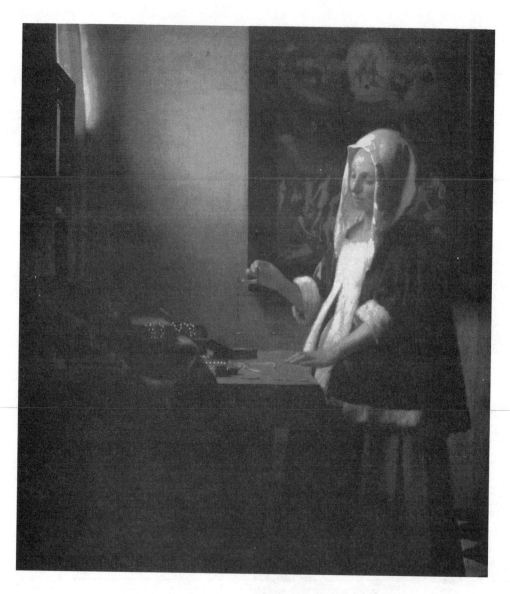

JAN VERMEER. *WOMAN HOLDING A BALANCE*.
c. 1664. Oil on Canvas, 16 3/4 x 15"
The National Gallery of Art, Washington, DC
Widener Collection, 1942
(Janson, p. 39, ill. 23)

How do the formal elements in the Picasso painting reinforce the planarity or 2-dimensional quality of the work, while those in the Vermeer reinforce the 3-dimensional spatial illusion of the painting?

PART ONE: THE ANCIENT WORLD

Janson, pp. 45-47

1. How is our concept of history related to the invention of writing?

2. Discuss the distinction between "prehistoric" and "historic" with regard to:

 a. the pace of change

 b. the nature of change

 c. human achievement

Chapter One: Prehistoric Art

The earliest images known to us, made by our direct ancestors, date from about 35,000 years ago. We believe that these images and objects, which are often quite visually sophisticated, were involved with purposes of magic and ritual.

The Old Stone Age Janson, pp. 50-54

1. How would you characterize the "life-styles" of our ancestors during the Paleolithic era (the Old Stone Age, c. 35,000 B.C. to c. 8,000 B.C., and later, depending on location)? (Please refer to pp. 45-46.)

2. Which three sites are often viewed as having among the finest examples of cave art?

 a.

 b.

 c.

3. What variety of animals is found in cave art, and how were the images painted and drawn on the walls and ceilings of caves?

4. Given the remarkable vitality of the cave paintings, and, in places, their restricted locations, what purposes might these images have served?

How might these purposes have linked image and reality through magic and ritual?

5. How does the notion of a chance resemblance, found in nature, joined with the powers of human imagination, produce a possible explanation of the origins of image-making?

6. What carved and/or painted objects were also part of the artistic legacy of the Paleolithic era?

受けつがれたもの

The New Stone Age Neolithic Era.

Janson, pp. 54-59

1. What significant changes in life-style characterize the New Stone Age which began in the Near East about 8,000 B.C.? (Please refer to pp. 46-47.)

技術

2. What new crafts and inventions were the result of these achievements?

場所
位置 produce 工芸品

3. What two sites have yielded important artifacts, and from them insights, into life during the New Stone Age?

明らかな

4. How do the Jericho skulls manifest the concept of "spirit traps?"

5. How would you describe the architecture of these communities?

6. How are the figurative images and objects from Catal Huyuk associated with similar images in Paleolithic art?

How might the differences between these Neolithic images and their predecessors be related to different purposes?

7. The most conspicuous Neolithic remains found in Northern Europe may be characterized as:

8. Define the following and give examples of each:

 a. dolmen

 b. cromlech

9. What evidence of Neolithic cultures is found in the Americas?

Chapter Two: Egyptian Art

The Old, Middle, and New Kingdoms Janson, pp. 60-77

In the ancient world, the transitions from Neolithic communities to civilization occured along the Nile river in Egypt, between the Tigris and Euphrates rivers in Mesopotamia, in the Indus Valley and Ganges river in India, and along the Huang Ho and Yangtze rivers in China. This important transition was characterized by a more complex and interrelated urban life-style.

The ancient Egyptian civilization endured from c. 3200 to c. 500 B.C. It was distinguished both by a remarkable stability of artistic forms as well as by innovation. The Egyptians were an extremely religious people, and much of the art which remains for us is associated with their belief in an afterlife.

Given the enormous time span of the Egyptian civilization, we divide Egyptian history according to three major periods of stability and economic prosperity. Fill in the blanks below to establish references for future use.

	DATES	DYNASTIES
Old Kingdom	———————	———————
Middle Kingdom	———————	———————
New Kingdom	———————	———————

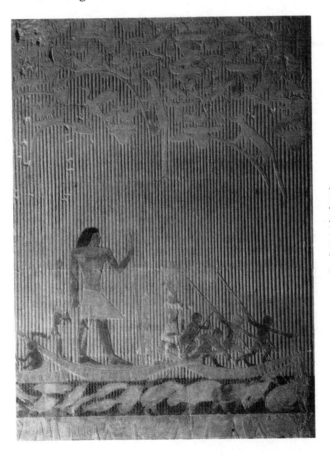

TI WATCHING A HIPPOPOTAMUS HUNT.
Painted limestone relief. c. 2400 B.C. Tomb of Ti, Saqqara (Janson, p. 70, ill. 68)

The above painting is a wall painting from an Old Kingdom tomb. The following two questions will introduce you to conventions of Egyptian art and significant aspects of Egyptian culture.

1. Describe the formal appearance of the figure of Ti.

おかしの

決りごと　生き生きと描く

How does this approach define a formula for depicting the figure in Egyptian art?

2 →

2. What is the purpose of these paintings in a tomb and how is that purpose associated with the Egyption concept of the *Ka*?

3. The following terms and persons are important to our understanding of Egyptian art. Define each of the terms and briefly examine the importance of the individuals named:

hieroglyph

Ka

King Zoser

mastaba

Imhotep

column

pyramid

scribe

portrait bust

Amun-Ra

Queen Hatshepsut

brick architecture

Akhenaten (Amenhotep IV)

Nofretete

Tutankhamen

4. How does the *Palette of Narmer* (Janson, p. 62, ills. 51,52) establish both visual and iconographic conventions which will guide Egyptian art for centuries?

5. How does the freestanding sculpted human figure relate to this mode of presentation?

6. How do Middle Kingdom portraiture and painting differ from those of the Old Kingdom? What historical circumstances might account for these changes?

7. Using the Temple at Luxor as an example, discuss the social hierarchy represented by the Egyptian temple.

Chapter Three: Ancient Near Eastern Art

Janson, pp. 78-97

From c. 3,500 B.C. to the 3rd century A.D., three major civilizations, the Sumerians, the Assyrians, and the Persians, prospered in the Near East. In the 6th and 5th centuries B.C., the Persian empire extended from the Mediterranean Sea to the Indian Ocean. The contributions made by these civilizations included schools, libraries, and developments in ethics, education, and law.

Our STUDY GUIDE *will consider these civilizations in the chronological order of their rise and prosperity.*

Sumerian Art

Janson, pp. 78-88

1. The Sumerian civilization, named after the region of

_____, developed between the _____

and_____rivers. Four important Sumerian sites were:

a.

b.

c.

d.

2. How do the history and culture of the Sumerians compare and contrast with their neighbors to the southeast, the Egyptians? In your response to this question, discuss "theocratic socialism."

3. Define and give an example of a *ziggurat*. How was the ziggurat both the religious and political center of a Sumerian city-state?

How does the ziggurat differ from Egyptian temple design?

4. How is the Sumerian sculptural style in stone (subtractive process) different from bronze or assembled figurative sculpture?

5. What purposes were served by these different forms of Sumerian sculpture?

How does Sumerian sculpture relate to that being done at the same time in Egypt?

6. The following terms, people, works of art and locations will contribute to our knowledge of the Sumerian civilization. Briefly define each:

cuneiform writing

mud brick and wood architecture

Sargon of Akkad

Stele of Naram-Sin

Guedea

Babylon

Code of Hammurabi

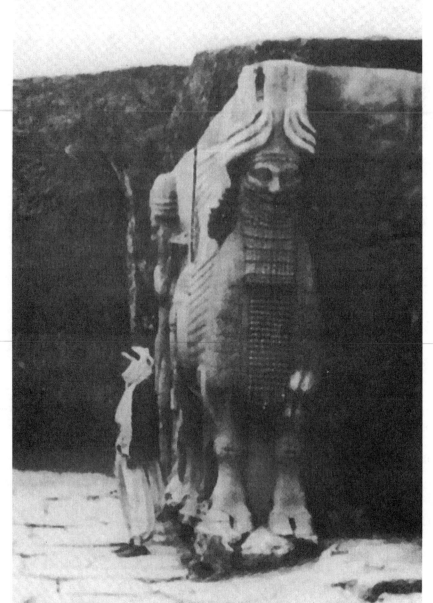

ASSYRIAN, *HUMAN HEADED WINGED BULL* (Lamassu),
from the Gateway, Citadel of Sargon II, c. 720 B.C.
Limestone, height 14'. Currently in the Musée du Louvre, Paris
(See Janson, p. 89, ill. 101, for another view.)

The above sculpture is from the Citadel of Sargon II. Its form and content reveal attitudes of Assyrian culture, especially the power of Assyrian rulers. Questions pertaining to this sculpture are on the following page.

1. How does the iconography relate to the ruling elite and notions of authority in Assyrian civilization?

2. How do the reliefs inside the Citadel of Sargon II reinforce the concept of royal authority?

How were these reliefs conceived differently from their Egyptian and Sumerian predecessors?

3. Name two other Assyrian sites and discuss how they are comparable to Dur Sharrukin:

 a.

 b.

1. How does the "animal style" relate to the origins of the Persian civilization?

2. How does the lack of religious architecture address Persian religious practice?

3. From an analysis of the Persian capital city of Persepolis, discuss adaptations from Egyptian and Assyrian artistic and architectural ideas. What features may be regarded as uniquely Persian?

4. Describe Persian art styles, and their roots, in the following periods:

Achaemenid

Sassanian

Chapter Four: Aegean Art

The Aegean Sea nourished three civilizations in the ancient world — the Cycladic, Minoan and Mycenaean peoples. For centuries, our understanding of these cultures was clothed in tales from ancient Greece, including Homer's Iliad. *Our direct knowledge of these cultures is relatively recent, and while much remains to be learned, they served as an important foundation for later civilizations, while retaining their own unique identities. From your reading, fill in the blanks below to reinforce your factual knowledge of these Aegean cultures.*

The ancient people whose home was the Cycladic Islands flourished between _____ and _____ B.C.; our knowledge of these people is primarily dependent on artifacts recovered from _____.

The Minoan culture, named after the legendary King _____, was located on the island of _____. Its development appears to have been affected by external violent changes, the first occurring about _____, and a second about _____. Excavations of the Minoan civilization were first conducted by _____ just before 1900.

The third Aegean civilization developed on_____from _____ to _____B.C. It is called the Mycenaean civilization after one of the settlements located at _____. This site was excavated by _____in the 1870's.

Cycladic Art

1. Among the most enigmatic remains of ancient art are the Cycladic idols which have been found in tombs. Describe the abstraction of these figures and discuss what possible purposes they might have served.

Is it possible that these idols might share a similar iconography with works from other cultures we have studied?

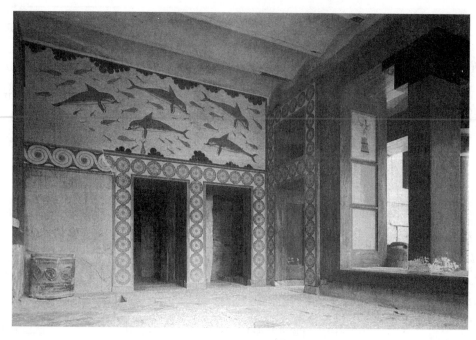

The Queen's Megaron, Palace of Minos, Knossos, Crete.
(Janson, p. 101, ill. 120)

1. Define megaron.

2. How is the large painting of marine life characteristic of both the abstract rhythms of early Minoan art, the Old Palace period (2,000-1700 B.C.), and the naturalism of later Minoan art, the New Palace period (1700-1500 B.C.)?

3. As a royal residence, how would you analyze the Palace of Minos at Knossos?

What is the importance of this structure in Greek mythology?

4. Discuss the complex iconography of the Minoan *"Snake Goddess"* (Janson, p. 102, ill. 121). What stylistic sources could have influenced this sculpture?

5. Compare and contrast Minoan with Egyptian painting.

Mycenaean Art Janson, pp. 106-109

1. Describe the burial practices of the Mycenaeans; how are these practices related to earlier civilizations which we have studied? What works of art have these tombs yielded?

2. What is the relationship of Mycenaean art to Minoan art?

3. Analyze the particular features of the Lioness Gate (Janson, p. 108, ill. 135) with reference to:

 a. the Mycenaean architectural tradition

 b. a possible influence from the Near East

4. How would you assess patterns of contact in the ancient world among Egyptian, Minoan, and Mycenaean peoples? How does the study of Art History help us to understand patterns of trade and cultural exchange?

Chapter Five: Greek Art

Janson, pp. 110-165

The ancient Greek civilization set the foundation for much of the cultural heritage in Europe and America. Echoes of Greek political thought, philosophy, art and architecture surround us today, yet we must not be misled by our familiarity. Our investigation of Greek culture and art, stripped from the veils of history, will reward us with fresh insight.

Greek art is distinguished by its rapid development; Greek artists were not content to repeat past formulae, but, ever searching to express an aesthetic ideal, continued to experiment and refine. From your initial reading on Greek art (Janson, pp. 110-114), answer the following questions.

1. What three sources provide information for the study of Greek art?

 a.

 b.

 c.

2. How did the following groups figure in the formation of ancient Greek civilization?

 a. Aeolians

 b. Dorians

 c. Ionians

3. Describe the political structure of Ancient Greece.

4. Among our earliest remains of Greek civilization are vases; how would you characterize the Geometric style of vase painting?

5. What was the purpose of the Dipylon vase (Janson, p. 111, ill.139)?

6. What is meant by the Orientalizing style? How did this style affect the development of narration in vase painting?

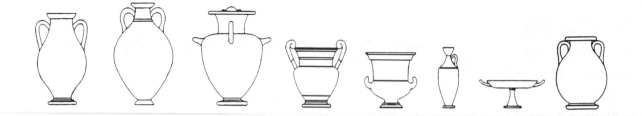

7. The typical Greek vase shapes are drawn above; label each shape with the letter of the correct title and with that title provide the purpose of the vase. Also, consider how the form of each vase responds to its purpose.

a. Amphora

e. Calyx Krater

b. Panathenaic Amphora

f. Lethykos

c. Hydra

g. Kylix

d. Volute Krater

h. Pelike

Archaic Vase Painting Janson, pp. 114-118

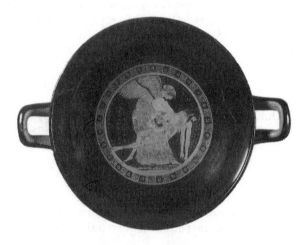

DOURIS. *EOS AND MEMNON*
Interior of an Attic red-figured kylix. c. 490-480 B.C.
Diameter 10 1/2". Musée du Louvre, Paris
(Janson, p. 117, ill. 145)

Questions pertaining to this object are on the following page.

1. The interior of this kylix demonstrates the red-figure technique. Describe this technique of vase painting.

2. This red-figure style was preceded by the black-figure style of vase painting; describe the black-figure technique.

3. Who originated the red-figure style and when did it become popular?

4. Assess the importance of pottery to our study of ancient Greek art. How did the production of pottery add to the economy of Greece, and of what significance is the fact that artists began to sign their works?

Archaic Sculpture Janson, pp. 118-124

1. How does the development of Greek figurative sculpture follow the influence of Egyptian art?

What is unique to Greek life-size figurative sculpture; how do these differences respond to different purposes?

2. Define the following types of sculpture according to both form and purpose:

 a. Kouros

 b. Kore

3. How would you characterize the development of Greek sculpture through the Archaic period?

4. Considering the Temple of Artemis at Corfu (Janson, pp. 122-123) and the the Temple of Aphaia at Aegena (Janson, p. 124), discuss the relationship of sculpture to architecture in Greek temple design.

Architecture Janson, pp. 124-139

1. What is meant by the term "architectural order?"

2. The three architectural orders are:

 a.

 b.

 c.

3. On the drawing below, label the parts and, with the help of the Glossary at the end of **Janson's** text, provide a short definition for each architectural element.

a. abacus	h. cornice	o. shaft
b. acanthus	i. echinus	p. stereobate
c. architrave	j. entablature	q. stylobate
d. astragal	k. euthynteria	r. triglyph
e. base	l. frieze	
		s. volute
f. capital	m. metope	
g. column	n. pediment	

 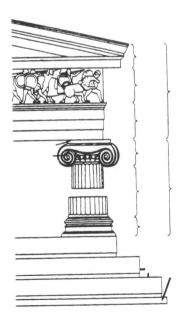 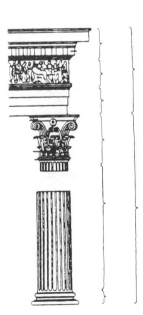

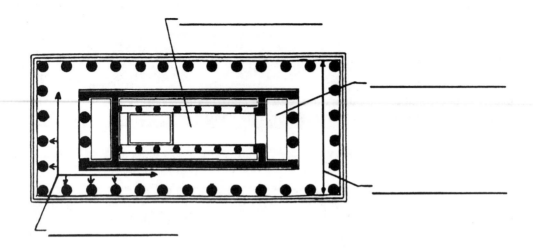

4. Identify and define the parts of the Greek temple plan above:

 a. cella or naos c. collonade or peristyle

 b. pronaos d. stylobate

5. Discuss the development of the Greek temple and the contributions from the following sources:

 a. Egypt

 b. Mycenae

 c. Pre-Archaic wood and mud brick architecture

6. How would you characterize the evolution of the Greek temple from those at Paestum (Janson, pp. 128-130) to the Parthenon (Janson, pp. 130-133)?

7. To assist our understanding of architecture and sculpture on the Acropolis in Athens, provide brief identifications for the following people and titles:

Peloponnesian Wars

Pericles

Ictinus and Callicrates

Parthenon's Refinements

Propylaea

Erechtheum

Caryatids

Phidias (see Janson, pp. 148-151)

8. Discuss the Greek contribution to town planning and to theater design.

9. How would you characterize the development of Greek architecture following the Peloponnesian War?

Classical Sculpture Janson, pp. 139-151

1. Define and give approximate dates for:

a. Severe Style

b. Classical Style

2. Define *contrapposto*; what is its importance in the evolution of figurative sculpture?

3. Citing two examples, discuss the ways in which the ancient Greek artist attempted to suggest movement in sculpture.

4. How would you characterize the "Phidian Style?"

Classical Painting Janson, pp. 151-153

1. What innovations in achieving illusionistic space occurred during the Classical period?

2. What traits distinguish late Greek vase painting?

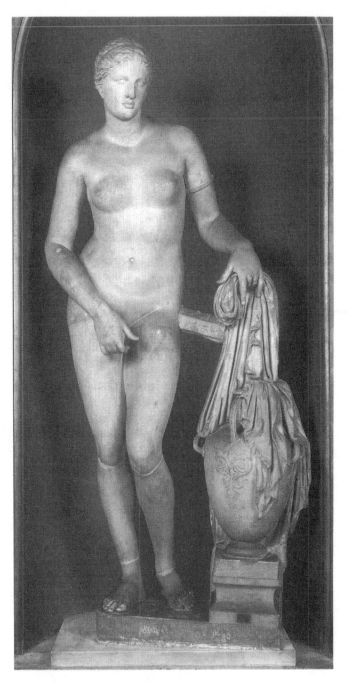

CNIDIAN APHRODITE.
Roman copy after an original
of c. 300 B.C. by Praxiteles.
Marble, height 6'8".
Vatican Museums, Rome
(Janson, p. 156, ill. 206)

1. The above work is a Roman copy after Praxiteles; how does it exemplify developments in fourth-century Greek sculpture?

2. How does this new concern with spatial involvement relate to contemporary developments in Greek painting?

3. How is fourth-century Greek culture distinguished from the later Hellenistic civilization?

Does the development of Greek art show a decisive break between these periods?

4. The Mausoleum at Halicarnassus was counted among the wonders of the ancient world. What was this monument and how might it be viewed as a summary of later Greek artistic developments and attitudes toward rulers?

5. Compare and contrast the relief sculpture of Scopas from the Mausoleum at Halicarnassus (Janson, p. 154, ill. 203) to the Parthenon frieze (Janson, p.149, ill. 194).

6. What innovations did Lysippus bring to fourth-century sculpture?

Hellenistic Sculpture Janson, pp. 158-162

1. What is the relationship between the representational and emotional imagery of Hellenistic sculpture and an audience which has expanded beyond the borders of the Greek mainland?

2. How is an empathetic communication achieved in the *Dying Trumpeter* (Janson, p. 159, ill. 210)?

3. How is portraiture related to Hellenistic culture?

4. Discuss the variety and purposes of the small statuette (Tanagra figures) in Greek life.

Coins Janson, pp. 162-165

1. How is the study of numismatics particularly relevant to the history of ancient Greece and Greek art?

SUMMARY CHART FOR GREEK SCULPTURE

To assist your understanding of the development of Greek sculpture,
select examples from the different periods cited below and delineate their
particular characteristics.

	WORK/DATE	CHARACTERISTICS
Archaic		
Severe		
Classical		
Fourth Century		
Hellenistic		

Chapter Six: Etruscan Art

Janson, pp. 166-175

During the 7th and 6th centuries B.C., the time of the Archaic Period in Greece, another civilization, that of the Etruscans, was flourishing on the Italian peninsula in the area between Florence and Rome. Although their origins remain uncertain, the Etruscans, in their loose confederation of city-states, made distinctive contributions to art and exerted significant influence on the later Roman civilization.

1. How is the terracotta sarcophagus from Cerveteri (Janson, p. 169, ill. 225, detail ill. 224) distinctive of an Etruscan style?

How does it exemplify Etruscan attitudes toward death?

2. How were Etruscan tombs designed?

3. What affinities does Etruscan tomb painting have with Minoan and Egyptian painting?

How is Etruscan painting distinctive?

4. From the fifth century B.C. onwards, Etruscan attitudes toward death changed. How is this change reflected in funerary art?

5. List four ways in which the Etruscan temple differs from the Greek temple.

 a.

 b.

 c.

 d.

6. How does the *Apollo* from Veii (Janson, p. 173, ill. 231), which once stood on the ridge of a temple roof, compare to a Greek kouros figure from the same time?

7. Discuss the importance of divination to Etruscan life.

8. The Etruscans made impressive contributions to urban architecture and design; what were these contributions and describe the plan of an Etruscan city.

Chapter Seven: Roman Art

Janson, pp. 176-211

Of all the civiliza-
tions in the ancient
world, Rome is the
most immediate to
the Western heritage.
As the Roman empire
reached from Great
Britain to North
Africa to the Near
East, ideas on urban
planning, architec-
ture, and art, how-
ever hybrid in their
origin, remain in
evidence even today.
Roman art was in-
fused with an histori-
cal consciousness;
Roman architectural
and engineering feats
joined splendor with
practicality.

1. What are some of the problems that we encounter in attempting to define "Roman art?"

How are these problems uniquely related to Roman attitudes toward the Greek civilization?

2. What was the role and status of the artist in ancient Rome?

1. From your reading and the use of the Glossary, label and define the parts of the arch and vaults below:

a. voussoirs

g. groin vault

b. keystone or crown

h. crown

c. extrados

i. haunch

d. introdos

j. groin

e. impost

k. bay

f. barrel vault

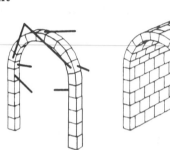 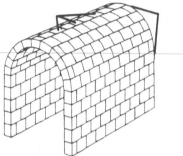 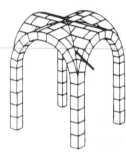

2. Roman architecture was both inventive and derivative; how is this Roman temple related to both Greek and Etruscan designs? What specific aspects of the design below are uniquely Roman?

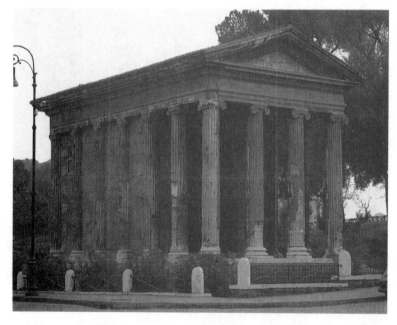 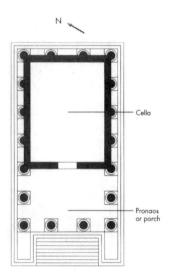

View and Plan, "Temple of Fortuna Virilis," Rome. Late 2nd century B.C.
(Janson, p. 178, ills. 236-237)

3. What is concrete and how did its use revolutionize Roman construction?

4. Analyze the chief architectural features of the Sanctuary of Fortuna Primigenia; how does the sanctuary uniquely relate to its site?

5. Analyze how the Romans adapted the use of the arch to fulfill the purposes of each of the following structures:

 a. Pont du Gard

 b. Colosseum

 c. Pantheon

 d. Basilica of Constantine

6. One of the most common types of building found throughout the empire was the basilica. The basilica was derived from Hellenistic Greece and usually adjoined a forum. On the reconstruction and plan below, identify and provide a short definition of the following parts (feel free to use Janson's Glossary as necessary):

 a. entrance c. apse

 b. nave d. clerestory

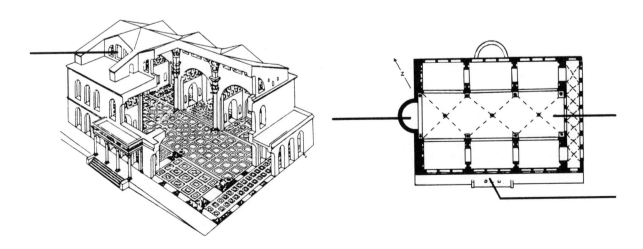

7. In Roman domestic architecture, how is the *domus* different from the *insula*?

8. How would you characterize the changes which take place in late Roman architecture?

What influences caused these changes?

Sculpture Janson, pp. 188-203

1. How does Roman figurative sculpture relate to the Greek tradition?

2. How did the functions of sculpture in ancient Rome differ from the Republican to the Imperial periods?

3. What is the derivation and significance of Roman portrait sculpture?

4. How did portraits and narration relate to the purposes of Roman Imperial art? Cite specific examples to illustrate your answer.

5. How does Roman pictorial relief sculpture relate to the illusionistic concerns of Roman painting (see Janson, pp. 203-211)? What does this say about the Romans' concern for defining their place in history?

6. How would you characterize changes in Imperial Roman portraiture through the time of Constantine?

How are these changes related to techniques of carving stone as well as cultural and historical events?

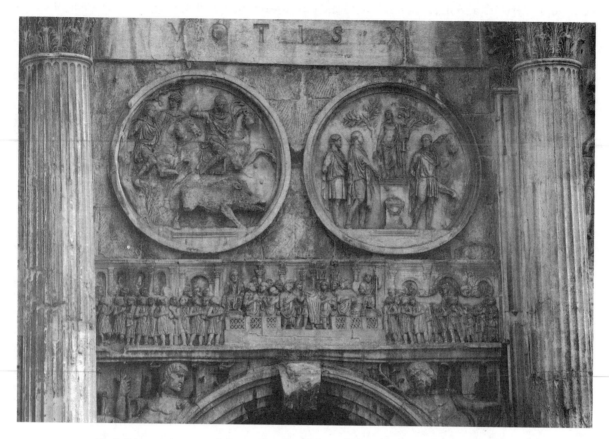

Medallions (117-138 A.D.) and frieze (early 4th century), Arch of Constantine
(Janson, p. 203, ill. 285)

7. How does the relief sculpture shown here, from the Arch of Constantine, exemplify the history of Roman Imperial figurative sculpture? Describe the formal changes which are evident between the earlier classicized reliefs in the circular areas at the top and the Late Antique horizontal relief below. What reasons are given for this changed attitude toward the figure in sculpture?

1. How is illusionism achieved in Roman painting; is the illusionism consistent with a single viewpoint?

2. What role do Greek sources play in our understanding of Roman painting?

3. Define the following:

 a. Faiyum Portrait

 b. encaustic

1.

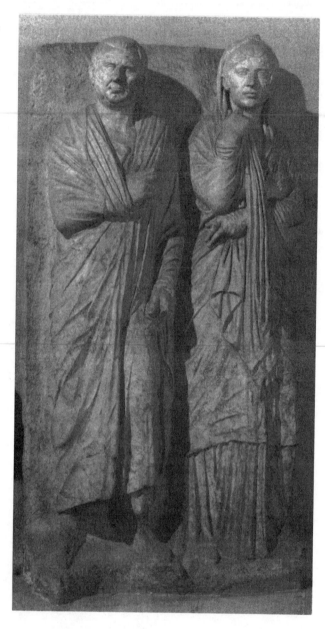

This first section of the SELF-REVIEW is meant to examine your skills in formal and iconographic reasoning. Study the work of art reproduced here (it is not to be found in Janson). Taking your lead from the questions which are asked, develop short essay answers which will support your identification of this work.

Culture: Approximate Date: Probable Purpose:

—————— —————————— ——————————

a. Analyze the presentation of the human figure; what cultures favored this type of portrayal?

b. Do you recall works of art from those cultures which are similar to this in appearance?

c. Is this an example of sculpture in the round or relief sculpture?

d. This form of sculpture might be associated with what purposes?

e. From your analysis of form and possible iconography, what conclusions can you draw with regard to culture, approximate date, and possible purpose?

. The second section of this SELF-REVIEW consists of forty multiple-choice and true/false questions.

1. Much of Egyptian funerary art was meant to serve the _____ in the afterlife.
 a. Sphinx
 b. Scribe
 c. Ka
 d. Pharaoh

2. Stonehenge exemplifies a _____.
 a. Dolmen
 b. Funerary precinct
 c. Cromlech
 d. Neolithic mound

3. The religious center of a Sumerian city-state was the _____.
 a. Pyramid
 b. Acropolis
 c. Megaron
 d. Ziggurat

4. In painting, a method of modeling in sharp contrast with light and shadow is termed _____.
 a. *chiaroscuro*
 b. perspective
 c. glazing
 d. relief

5. The nucleus of a Greek, Etruscan, or Roman temple, where the image of the diety was placed, is termed _____.
 a. Peristyle
 b. Stylobate
 c. Cella or Naos
 d. Architrave

6. The unique Roman temple that was dedicated to "all the gods" and combined a cylindrical domed cella with a standard temple porch is the _____.
 a. Parthenon
 b. Sanctuary of Fortuna Primigenia
 c. Temple of Sibyl
 d. Pantheon

7. The Minoan structure whose complex design gave rise to the Greek legend of the labyrinth of the Minotaur is the _____.
 a. Palace of Minos at Knossos
 b. Treasury of Atreus
 c. Temple of Aphaia
 d. Citadel of Sargon II

8. Art Historians have distinguished three phases of Roman wall painting.
 a. true
 b. false

9. _____distinguishes art from craft.
 a. Representation
 b. Imagination
 c. Purpose
 d. Originality

10. Sculpture which is tied to the background, from which it only partially emerges, is termed
_____.
 a. free-standing sculpture
 b. relief sculpture

11. The most striking works of Paleolithic art are images of _____.
 a. animals
 b. humans
 c. landscapes
 d. still lifes

12. _____ was a Neolithic community which has yielded important remains.
 a. Lascaux
 b. Sumer
 c. Stonehenge
 d. Jericho

13. Themes of conflict and violent change typify Minoan art.
 a. true
 b. false

14. Greek Tragic theater had its origins in rites honoring the god _____.
 a. Zeus
 b. Hermes
 c. Dionysus
 d. Ares

15. In the ancient Aegean, Mycenaean art developed without reference to Egyptian and Minoan art
and practices.
 a. true
 b. false

16. In ancient Persia, the ambitious and splendid palace begun by Darius I in 518 B.C. was located
at _____.
 a. Babylon
 b. Teheran
 c. Naksh-i-Rustam
 d. Persepolis

17. The work of art from the beginning of Egyptian dynastic history, which sets the formal conven-
tions of Egyptian figurative art, is the _____.
 a. Mastaba of Zoser
 b. Great Sphinx
 c. *Palette of Narmer*
 d. *Bust of Prince Ankh-Haf*

18. The Egyptian ruler who unsettled many of his country's social, religious, and artistic practices was _____.
 a. Akhenaten
 b. Tutankhamen
 c. Chefren
 d. Zoser

19. The earliest known monument to the glory of a conqueror is the _____.
 a. stele with the Law Code of Hammurabi
 b. *Victory Stele of Naram-Sin*
 c. the relief of Saphur I triumphing over the Emperor Philippus the Arab
 d. the Ishtar Gate

20. The Lyon Gate is an impressive remain from the_____civilization.
 a. Minoan
 b. Mycenaean
 c. Archaic Greek
 d. Egyptian

21. Compared to the animals of Paleolithic Art, those of the Neolithic Period are_____.
 a. simplified and immobile
 b. just as lively
 c. a different species
 d. non-existent

22. The "bent-axis approach" is a fundamental characteristic of _____ religious architecture.
 a. Egyptian
 b. Greek
 c. Roman
 d. Mesopotamian

23. The "animal style" was a feature of _____.
 a. Egyptian Art
 b. Persian Art
 c. Mycenaean Art
 d. Cycladic Art

24. "Effigy Mounds" are Neolithic monuments, constructed by prehistoric Indians, in North America.
 a. true
 b. false

25. The Greek artist who worked with both the black-figured and the red-figured technique is _____.
 a. Heracles
 b. Phidias
 c. Exekias
 d. Psiax

26. In ancient Egypt, the portrait bust was an invention of Old Kingdom art.
 a. true
 b. false

27. The first people in history to write at length about their own artists were the _____.
 a. Egyptians
 b. Sumerians
 c. Romanss
 d. Greeks

28. The Romans advanced the use of the arch and concrete in construction.
 a. true
 b. false

29. The architectural order of the Parthenon is _____.
 a. Corinthian
 b. Ionic
 c. Doric

30. The ancient Romans displayed a great admiration for Greek art.
 a. true
 b. false

31. The pre-Roman people whose culture possessed a lively, individual art style, and who passed on significant contributions to the Romans, were the _____.
 a. Archaic Greeks
 b. Assyrians
 c. Etruscans
 d. Minoans

32. Roman wall painting may be described as being consistently flat or "2-D."
 a. true
 b. false

33. The best preserved Greek temples are actually located in Southern Italy.
 a. true
 b. false

34. The Parthenon is a monument from _____.
 a. Archaic Greece
 b. Classical Greece
 c. the Hellenistic world
 d. Rome

35. The new articulation of the body which appeared in Greek Art c. 480 B.C., and which demonstrates the proper weight distribution for a body at rest, is termed _____.
 a. *chiaroscuro*
 b. composition
 c. free-standing
 d. *contrapposto*

36. The great pyramids at Giza were solid structures which marked the underground burial spot of the pharaoh.
 a. true
 b. false

37. _____ is credited with inventing the expressive role of the column in architecture.
 a. Imhotep
 b. Ictinus
 c. Anthemius of Tralles
 d. Isidorus of Miletus

38. Understanding a work of art begins with a sensitive appreciation of its appearance.
 a. true
 b. false

39. Etruscan sculptors, unlike their Greek counterparts, preferred additive processes in creating figurative sculpture.
 a. true
 b. false

40. A private Roman house was called an *insula*.
 a. true
 b. false

Discussion Questions:

1. Discuss the ways in which art has been used as a vehicle to link the physical with the spiritual world in Prehistoric and Ancient Western societies.

2. In ancient civilizations, how have art and architecture been used to glorify rulers and political regimes?

3. How did the status of the artist vary among ancient cultures?

4. Discuss the development of the human figure in art from the Egyptian to the Late Roman (Late Antique) civilizations.

5. In what ways do primary sources assist our understanding of art in the ancient world?

PART TWO: THE MIDDLE AGES

The Middle Ages Janson, pp. 225-227

1. During the Middle Ages, the "center of gravity" of European civilization shifted to Northern Europe. Name three events which contributed to this shift:

 a.

 b.

 c.

2. The rise of Islam was a powerful new force in the Middle Ages; how did the rapid expansion of the Islamic empire contribute to the realignment of the church with rulers in Northern Europe?

3. Why did Charlemagne, crowned Holy Roman Emperor in Rome in 800, choose to rule the Western Empire from Aachen, and not from Rome?

4. How did the relationship between church and state develop differently in the West than in the Byzantine Empire?

5. Cite four contributions which have come to us from the Islamic culture:

 a.

 b.

 c.

 d.

Chapter One:
Early Christian and Byzantine Art

Janson, pp. 230-269

The Emperor Constantine proved to be a pivotal figure in Western history. He legalized the Christian religion in the Roman empire in 313 A.D., and ten years later decided to move the capital city to the Eastern Provinces. The new status of Christianity significantly assisted the development of Early Christian art, while the new capital, Constantinople, would become the political center of the later Byzantine Empire.

1. What was the role of the Roman Emperor Constantine in the development of Early Christian art, especially architecture?

2. How did Constantine set the foundation for the later Byzantine civilization?

3. How do paintings from Dura-Europos (Janson, pp. 231-233, ill. 295) compare to earlier Roman painting? How are these changes similar to those found in Late Antique sculpture?

Early Christian Art Janson, pp. 233-249

1. What does the imagery of catacomb painting express?

2. How did the catacomb painter use a "traditional vocabulary to convey a new, symbolic content" (Janson, p. 234)?

3. Utilizing the diagram below, label and provide a short definition of the parts of a cruciform basilica church.

a. aisles

b. altar

c. apse

d. atrium

e. bema (transept)

f. narthex

g. nave

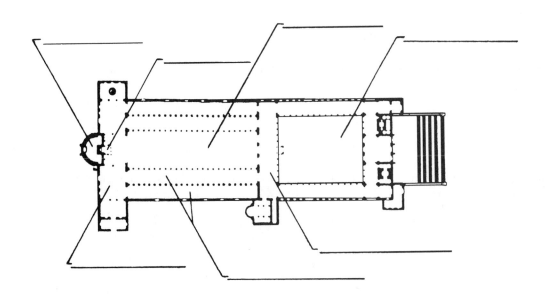

4. How is the cruciform basilica church similar to, yet different from its predecessor, the Roman basilica?

5. How does the exterior design relate to the interior decoration of these Early Christian churches?

6. How do the above discussed differences, which distinguish the Early Christian basilica church, relate to the beliefs and practices of the Christian faith?

7. How did the Early Christian community make use of domed structures?

8. How did the mosaic medium suit the decorative purposes of the Early Christians?

9. How do Early Christian mosaics contrast with the illusionism of earlier Greco-Roman painting? Please refer to specific mosaics and paintings when developing your answer.

10. Define the following terms as they relate to Early Christian roll and book illustration:

 a. parchment or vellum

 b. codex

 c. illumination

 d. continuous narration

11. How did the advent of the codex affect the development of illustration?

12. How did the biblical prohibition against graven images affect the development of sculpture in Early Christian art?

13. Cite two examples of Early Christian art which display strong classical attitudes. How do we explain these continuing threads of classicism in Early Christian art?

14. How does Early Christian portraiture relate to those formal tendencies which we first encountered in Late Roman art?

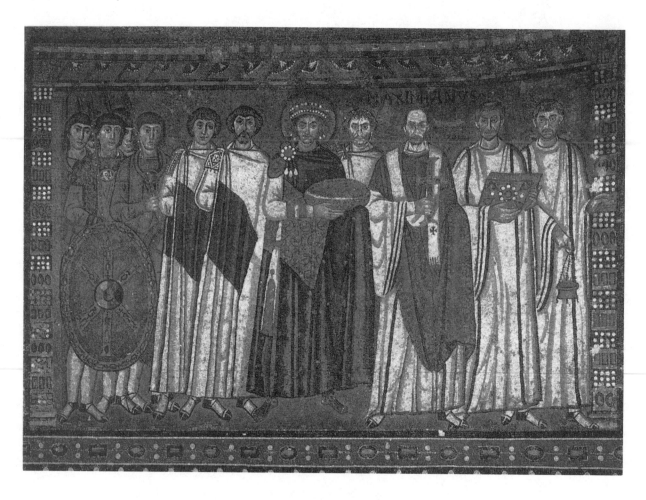

EMPEROR JUSTINIAN AND HIS ATTENDANTS.
Mosaic, c. 547 A.D. S. Vitale
(Janson, p. 251, ill. 321)

1. The above mosaic represents the Byzantine Emperor Justinian and his court. In style and iconography, this mosaic exemplifies values of Byzantine art and civilization. Explain how:

2. How is Hagia Sophia in Constantinople a unique synthesis of the basilica plan and a domed structure?

3. Describe how a dome is raised on pendentives.

4. How does Hagia Sophia integrate light with our experience of the building?

5. What was the Iconoclastic Controversy and how did it affect religious and secular art?

6. What factors distinguish Byzantine art and architecture following the Iconoclastic Controversy, i.e., after 843?

7. How did the use of wood as a building material affect the transformation of Byzantine architecture in Russia?

8. What continuing artistic values, derived from Classical Antiquity, are found in Byzantine art, especially manuscript illuminations and mosaics, following the Iconoclastic Controversy? Cite specific examples to illustrate your answer.

9. What is the meaning, genesis, and purpose of an Icon (see Janson, pp. 254-257; 267-268)?

10. Why is there a strong repetition of formal rules in Icon painting?

Chapter Two: Early Medieval Art

The Early Medieval Period in Western Europe, commonly but mistakenly known as "the Dark Ages," was a time of vital cultural activity. The 7th and 8th centuries witnessed the flowering of the Irish culture, whose monasteries significantly contributed to the cultural revitalization of Europe. Later, Charlemagne sought to revive the political unity and cultural ideas of the Roman world, and, in the 10th century, the Ottonian rulers brought the German artistic legacy to the forefront.

Janson, pp. 270-291

1. Why is the past reference to the Middle Ages as an "age of darkness" no longer valid in our consideration of Medieval culture and art?

2. Name four properties of the "animal style" in Celtic-Germanic art:

 a.

 b.

 c.

 d.

3. What was the principle medium of the "animal style?" How is this medium characteristic of this culture?

4. Define Hiberno-Saxon; on what artistic tradition is the art of this culture based?

5. Describe the importance of Irish monasteries in Europe in the 7th and 8th centuries.

6. Define *scriptoria*; why were monasteries involved in the production of manuscripts?

7. Viewing the Cross Page from the *Lindisfarne Gospels* (Janson, p. 272, ill. 352), how was Celtic-Germanic animal style transformed to Christian purposes?

8. How does the treatment of the human figure in Hiberno-Saxon art contrast with the Mediterranean (Classical) tradition of Greece and Rome?

Carolingian Art Janson, pp. 275-282

1. How is the Carolingian Revival responsible for preserving texts of Classical authors?

2. What two elements did the Carolingian Revival seek to fuse?

 a.

 b.

3. How does the Palace Chapel of Charlemagne at Aachen, designed by Odo of Metz, compare with its prototype, the Byzantine church of San Vitale in Ravenna (Janson, pp. 249-251, ills. 318-322)?

4. Define the following elements as they apply to Carolingian architecture:

 westwork

 crossing tower

 choir

5. What features would lead to the conclusion that a monastery was a "complex, self-contained unit?"

6. The illumination of *St. Matthew* (Janson, p. 280, ill. 365) was completed during the Carolingian Roman Revival. How is this image different from Hiberno-Saxon and Lombard representations of symbols of the evangelists?

How does *St. Matthew* respond to the Classical tradition?

7. How does the quality of line in the *Gospel Book of Archbishop Ebbo* and the *Utrecht Psalter* (Janson, p. 281, ills. 367 and 368) serve to energize the composition?

Ottonian Art Janson, pp. 282-291

1. How does the crucified Christ on the *Lindau Gospel* cover (Janson, p. 283, ill. 369) compare and contrast with the Christ of the *Gero Crucifix* (Janson, p. 284, ill. 370)?

How does the latter Ottonian work betray the influence of Byzantine art?

2. How did cultural and artistic leadership pass to Germany from the mid-10th to the early 11th century?

3. In terms of surviving works, why is Bishop Bernward of Hildesheim considered the most "ambitious patron of architecture and art in the Ottonian age" (Janson, p. 286)?

4. Name two artistic sources for Ottonian manuscript painting and discuss how this blend resulted in a new and powerful style of illustration:

 a.

 b.

Chapter Three: Romanesque Art

Janson, pp. 292-319

During the mid-11th century, amid an economic, social, and cultural revival, the Romanesque style took hold throughout Europe. As the name implies, the Romanesque style adapted ancient Roman architectural and artistic elements to the Christian religious enthusiasm of the time. Art objects created in earlier Medieval workshops, such as manuscript illuminations, ivory carvings, and metalwork, continued to be produced. The century, however, was particularly distinguished by a revival of monumental architecture and sculpture.

ST. MARK, from a Gospel Book produced at Corbie
c. 1050. Bibliothèque Municipale, Amiens
(Janson, p. 313, ill. 414)

1. In discussing the above manuscript painting, Janson (p. 313) states that "the representational, the symbolic, and the decorative elements of the design are knit together into a single unified structure." Identify these three elements and discuss how they are interwoven in this image.

2. What aspects of these elements are rooted in earlier Medieval artistic traditions?

3. How do these elements find expression in other media during the Romanesque period, especially portal sculpture and metalwork?

4. Name four factors which accounted for the new cultural vitality of Western Europe during the Romanesque period (see Janson, pp. 292-293):

 a.

 b.

 c.

 d.

5. Accepting that Europe was in many ways "Roman-like" in the 11th century, cite one important way in which it was not.

1. The Romanesque period witnessed a dramatic increase in building activity; name two ways in which Romanesque churches were distinctive from their predecessors:

 a.

 b.

2. How widespread was the Romanesque style in Europe?

3. Viewing the plan below, label and provide a short definition of the features of a Romanesque church:

a. aisles	f. crossing
b. ambulatory	g. nave
c. apse	h. radiating chapels
d. bay	i. towers
e. choir	j. transept

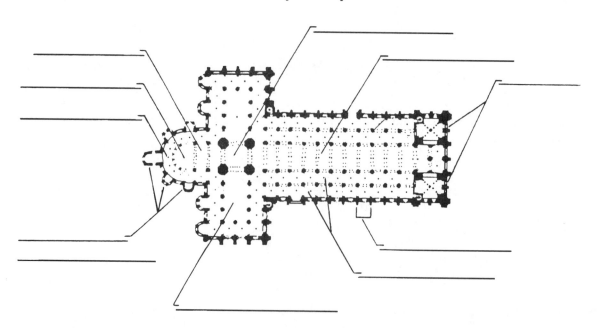

4. Viewing the plan, exterior, and interior of St. Sernin (Janson, pp. 294-295, ills. 380-383), how would you define the Romanesque "Roman-like" elements of this church?

5. How are these elements similar to, yet also different from, those found in surviving examples of Roman architecture?

6. Vaulting added to the aesthetic presence of a Romanesque church; what practical purpose did stone vaults also serve in the construction of these churches?

7. Define triforium; how is it used in the elevation at Autun Cathedral (Janson, p. 295, ill. 384)?

8. How was the three-story elevation made possible at Autun Cathedral?

9. Define "Hall Church;" how are these churches different from the nave articulation discussed above?

10. Considering the Romanesque regional style in England and Normandy, what innovations were made in the design of Durham Cathedral (Janson, p. 299, ills. 388-390)?

11. In the diagram below, label and define the vocabulary of the rib vault:

a. bay

c. diagonal rib

b. boss

d. transverse rib

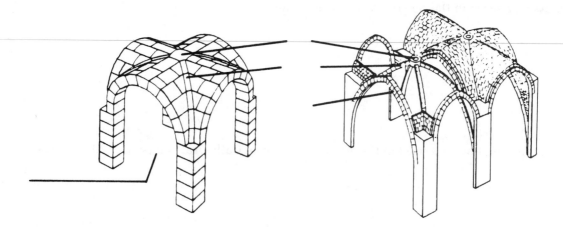

12. How does the use of ribs reduce the weight and thrust of the vault?

13. From selected examples, characterize the regional variations of Romanesque architecture:

	EXAMPLE	CHARACTERISTICS
Lombardy		
Germany and Low Countries		
Italy		

1. Much, but certainly not all, Romanesque sculpture centered around the entrances to churches. Using the diagram below, label and define the fields for Romanesque relief sculpture:

 a. archivolts d. trumeau

 b. jambs e. tympanum

 c. lintel

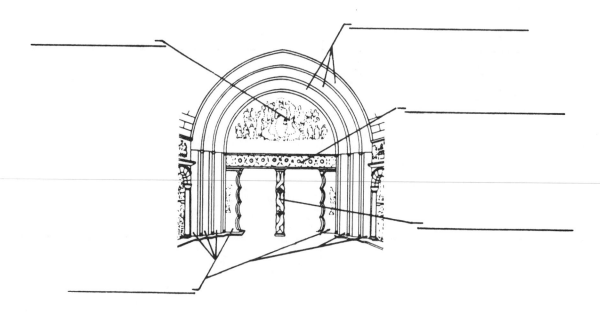

2. What was the purpose of Romanesque portal sculpture?

3. How did the Romanesque artist combine representational forms with fantastic creatures to achieve this purpose?

4. What Classical values are found in Romanesque sculpture?

5. Who was Benedetto Antelami, where did he work, and how are his sculptures particularly responsive to the Classical tradition?

6. How is the emergence of the artistic personality associated with the Romanesque period?

Painting and Metalwork Janson, pp. 313-319

1. The *Bayeux Tapestry* (Janson, p. 314, ill. 415) was created most probably through a collaboration of women artists. How do the elements of narration and ornament interact in the composition of this embroidered frieze?

2. Citing two examples from your reading, discuss what changes occurred in Romanesque manuscript painting after the mid-12th century? In what medium did these changes originate?

3. Discuss the activities of women artists during the late Middle Ages.

4. Discuss how, in the late 12th century, the reawakened interest in humanity and nature found artistic expression in the *Carmina Burana* (Janson, p. 318-319, ill. 422).

Chapter Four: Gothic Art

Janson, pp. 320-387

Between 1137 and 1144, in the church of St. Denis just outside of Paris, the culminating style of the Middle Ages, the Gothic, was born. First defined in architecture, later the Gothic style nourished significant and diverse developments in sculpture and painting. The Gothic style, characterized by elegance and decoration, spread quickly throughout Europe, continuing into the 15th century.

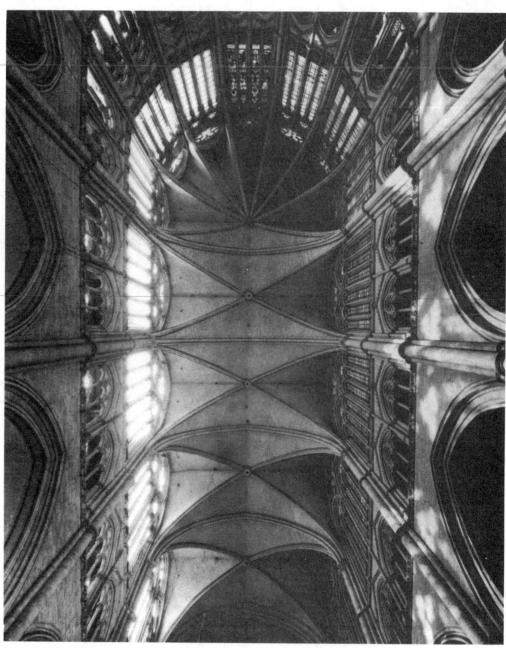

Choir Vault, Amiens Cathedral. Begun, 1220
(Janson, p. 331, ill. 438)

From our viewpoint looking directly up into the choir vault of Amiens Cathedral, the following questions are meant to substantiate our understanding of both the aesthetics and the structural systems of Gothic architecture:

1. What kind of vault is evident here?

2. Is the arch rounded or pointed?

3. How would you characterize the articulation of the elevation? Is there a dominant design emphasis?

4. What kind of windows are used?

5. Name two purposes, iconographic and aesthetic, which these windows served:

 a.

 b.

6. What structural system, with regard to buttressing, would allow this vast amount of window space?

Introduction Janson, p. 320

1. Briefly outline the evolution of the Gothic style in:

 architecture

 sculpture

 painting

2. Identify the terms *opus modernum* and *opus francigenum*.

3. Explain how the Gothic style may be considered both international and regionally independent at the same time.

Architecture Janson, pp. 321-343

1. What was the role of Abbot Suger in the birth of the Gothic style in architecture?

2. How did Suger join both "spiritual politics" and practical politics in his plans for St. Denis?

3. How are the choir and radiating chapels of St. Denis, rebuilt by Suger, different from a Romanesque church?

How would you characterize the result of this new plan?

4. Name two characteristics of the new Gothic style which distinguished it from its predecessors:

 a.

 b.

5. Structurally, how are these effects, which you have cited above, obtained?

6. How would you describe the birth of the Gothic architectural style with regard to the individual elements in Suger's plan (i.e., pilgrimage choir plan, pointed arch, ribbed groined vault)? Are these individual elements new to Gothic architecture?

7. How are the qualities of light and numerical symbolism, derived from Pseudo-Dionysius, associated with the birth of the Gothic style?

8. Define *respond*; how does form express function in the interior of a Gothic church?

9. How was Gothic architecture, with its urban orientation, responsive to the changed social, economic, religious, and educational conditions of the Late Middle Ages?

10. How does the flying buttress contribute to both the structure and aesthetics of a Gothic church?

11. How is the design of a Gothic church facade similar to, yet different from, a Romanesque facade?

12. What cathedral is viewed as the first masterpiece of the High Gothic style? On what basis is this attribution made?

13. Along with the refinements of structure in the above mentioned cathedral, what other aspect of this cathedral is most noteworthy?

14. How does the phrase "refinement of detail, rather than towering monumentality" (Janson, p. 334) describe late Gothic architecture?

15. Define Flamboyant Gothic; how may this variation of the style be viewed as the structural and decorative culmination of Gothic architecture?

16. What impact did the Gothic style have on secular architecture?

17. How was the Cistercian religious order responsible, in part, for the spread of the Gothic style?

18. Define "Perpendicular Style;" how does it apply to the English adaptation of the French Gothic style?

19. How is Italian Gothic architecture, as exemplified in the abbey church at Fossanova (Janson, p. 339, ills. 455-456) and Sta. Croce in Florence (Janson, p. 340, ills. 457-458), a blend of Gothic qualities and Mediterranean tradition?

20. Compare and contrast the Palazzo Vecchio in Florence (Janson, p. 343, ill. 464) and the Ca'd' Oro in Venice (Janson, p. 343, ill. 465). How may both of these structures be considered Gothic, while each reflects a different cultural milieu?

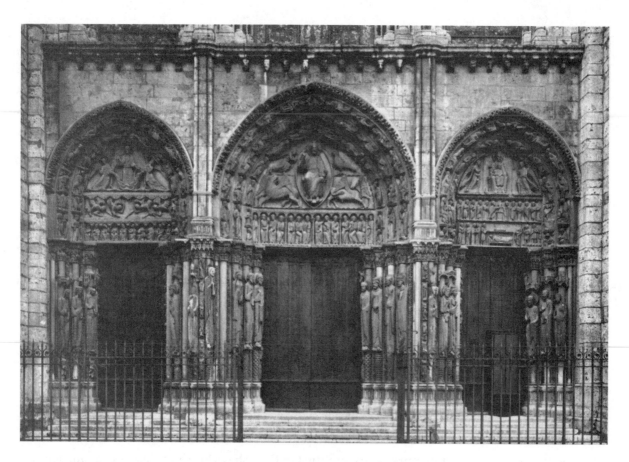

West Portal, Chartres Cathedral. c. 1145-70.
(Janson, p. 344, ill. 466)

1. List four ways in which the portal sculpture of Chartres Cathedral differs from its Romanesque predecessors:

 a.

 b.

 c.

 d.

2. How is the novel treatment of jamb sculpture important to the reintroduction of monumental sculpture in the West?

3. How did the religious iconography of the West Portal make reference to contemporary royal authority in France?

4. Define Gothic Classicism; did this Classical strain continue throughout the Gothic period?

5. What is meant by Gothic Realism?

6. How would you characterize the Gothic sculptural styles of the Naumburg Master and Claus Sluter? Cite specific examples of their work in developing your essay.

7. Compare and contrast the *Nativity* relief sculptures of Nicola Pisano (Janson, p. 353, ill. 483) and his son Giovanni Pisano (Janson, p. 354, ill. 485) with regard to Classical and Gothic formal tendencies.

8. Define International Style and analyze the work of one sculptor and one painter who exemplify this style.

 sculptor:

 painter:

9. What spatial innovation, the first since antiquity, is found in Ghiberti's *Sacrifice of Isaac* panel (Janson, pp. 357-358, ill. 492)?

Painting Janson, pp. 358-381

1. Describe the technique of creating a stained glass window.

2. How is the stained glass medium integral to Gothic architecture with regard to structure, aesthetics, and iconography?

3. Who was Villard de Honnecourt; how would you describe his concept of "drawing from life?"

How is this interpretation in accord with Medieval thought?

4. How was Master Honoré able to introduce a limited spatial range into his illuminations (Janson, p. 362, ill. 498)?

5. Define the following media:

 tempera

 fresco

 sinopia

6. How is Cimabue's *Madonna Enthroned* (Janson, pp. 363-364, ill. 499) related to, and yet different from, the Byzantine artistic tradition which exerted a strong influence on Medieval Italian painting?

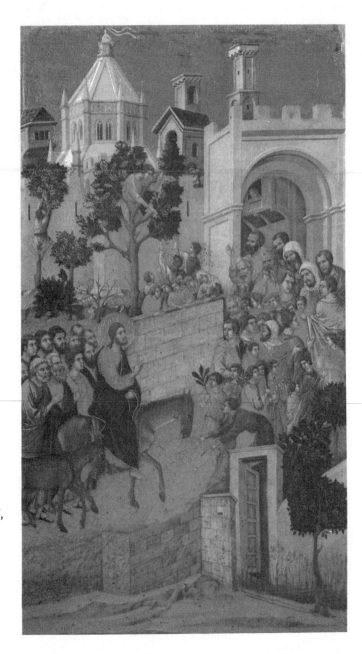

DUCCIO. *CHRIST ENTERING JERUSALEM*,
from the back of the *Maestà Altar*. 1308-11.
Tempera on panel, 40 1/2 x 21 1/8."
Museo dell' Opera del Duomo, Siena
(Janson, p. 365, ill. 502)

7. What is traditional and what is novel about the treatment of illusory space in Duccio's painting?

8. How do the spatial concerns displayed in Duccio's work relate to Gothic facade sculpture?

9. What innovations were brought about by Giotto? How is Giotto's *Lamentation* (Janson, p. 368, ill. 506) exemplary of these innovations?

10. What artistic influences contributed to Giotto's style?

11. How is Pietro Lorenzetti's *Birth of the Virgin* (Janson, p. 371, ill. 509) novel in its treatment of the pictorial surface as a transparent window?

12. How did the Black Death affect the iconography of mid to late 14th-century Italian painting?

13. Examine Jean Purcelle's contribution to opening up of pictorial space in Late Gothic painting in Northern Europe.

14. Define *drôlerie*; what is its purpose in manuscript painting?

15. Discuss the contributions of the following artists to the International Style:

Limbourg Brothers

Gentile da Fabriano

Analyze the formal qualities, iconography, and evident physical structure of this object as you answer the questions below.

Style: Approximate Date:

_____ _____

Iconography: Purpose: Probable Site:

_____ _____ _____

a. From your analysis of the physical structure of this object, what is the probable medium?

b. From your knowledge of two famous tempera paintings of the same subject (Janson, p. 363, ill. 499 and p. 369, ill. 507), what is the iconography of this image?

c. What are the formal characteristics of this image; how do they relate to the artistic tradition of the Middle Ages?

d. What type of structure usually housed this medium?

e. Which of these structures that you have studied was particularly famous for its display of art in this medium?

This second section of your SELF-REVIEW consists of forty multiple-choice and true/false questions.

1. The first true landscape achieved since Roman times, the *Good Government* fresco in Siena, was painted by:
 a. Giotto
 b. Simone Martini
 c. Ambrogio Lorenzetti
 d. Francesco Traini

2. The Roman Emperor who recognized Christianity and moved the capital to Byzantium was _____.
 a. Augustus
 b. Trajan
 c. Marcus Aurelius
 d. Constantine

3. The ruler who revived the imperial ambitions of Charlemagne in 962 A.D. was:
 a. Gero
 b. Charles the Bald
 c. Otto I
 d. Bernwald

4. During the Middle Ages, the interdependent dualism of spiritual and political authority of Church and State would distinguish Western Europe from both the Orthodox East and the Islamic South.
 a. true
 b. false

5. In the Celtic-Germanic style, the principal medium of the animal style was _____.
 a. manuscript illumination
 b. monumental sculpture
 c. relief sculpture
 d. metalwork

6. The greatest Italian painter of the International Style was _____.
 a. Giotto
 b. Masaccio
 c. Gentile da Fabriano
 d. Leonardo

7. The origin of the Gothic style was with Abbot Suger and the Florence Cathedral.
 a. true
 b. false

8. Early Medieval manuscripts were usually produced in _____.
 a. guild halls
 b. libraries
 c. monasteries
 d. publishing houses

9. Ottonian Art relates to the rule of Charlemagne at Aachen.
 a. true
 b. false

10. The Medieval architectural style which revived Roman architectural concepts on a major scale is termed _____.
 a. Romanesque
 b. Carolingian
 c. Ottonian
 d. Gothic

11. The synagogue mural at Dura-Europos, composed from a variety of formal elements, is meant to serve a spiritual truth.
 a. true
 b. false

12. The *Bayeux Tapestry*, probably created by a group of women artists, depicts _____.
 a. Charlemagne being crowned in Rome in 800
 b. Abbot Suger at St.-Denis
 c. the Adoration of the Magi
 d. William the Conqueror's invasion of England

13. In a Romanesque portal, the semi-circular area over the door, which usually contained relief sculpture, is termed the _____.
 a. lintel
 b. trumeau
 c. tympanum
 d. jamb

14. The time from 726 to 843 in the Byzantine Civilization, during which the use of images in worship was questioned, is called the Iconoclastic Controversy.
 a. true
 b. false

15. The usual medium for late Medieval panel painting was _____.
 a. fresco
 b. oil
 c. encaustic
 d. tempera

16. The artist who revolutionized Italian painting in the opening years of the 14th century was _____.
 a. Ghiberti
 b. Duccio
 c. Giotto
 d. Cimabue

17. Ribbed groined vaults, pointed arches, stained glass windows, and flying buttresses are all characteristic of what kind of a building?
 a. Islamic mosque c. Romanesque church
 b. Carolingian church d. Gothic church

18. The *Sarcophagus of Junius Bassus* is a key example of Early Christian figurative sculpture.
 a. true
 b. false

19. The human figure in Hiberno-Saxon Art is thoroughly realistic.
 a. true
 b. false

20. The monumental entrance structure to a church, the origins of which are rooted in the Carolingian Period, is called a(n) _____.
 a. narthex
 b. atrium
 c. westwork
 d. ambulatory

21. St. Michael's, Bernward's church at Hildesheim, was an architectural monument from what period?
 a. Romanesque
 b. Carolingian
 c. Ottonian
 d. Gothic

22. Manuscript miniatures are, in places, referred to as _____.
 a. illuminations
 b. encaustic paintings
 c. scriptoria
 d. tempera paintings

23. The Celtic-Germanic animal style influenced Hiberno-Saxon Art.
 a. true
 b. false

24. Medieval monasteries only consisted of a church and a parish house.
 a. true
 b. false

25. Charlemagne's Palace Chapel at Aachen was inspired by _____.
 a. St. Peter's
 b. the Basilica of Constantine
 c. the Pantheon
 d. San Vitale

26. Romanesque churches usually favored _____.
 a. pointed arches
 b. groined vaults
 c. barrel vaults
 d. wooden coffered ceilings

27. Romanesque churches adapted the cruciform basilica plan of the Early Christian churches.
 a. true
 b. false

28. Toward the year 1400, the single dominant style present throughout Western Europe is called the _____.
 a. Animal style
 b. Lombard style
 c. Carmina Burana style
 d. International Style

29. Gothic portal sculpture brought a new sense of order, emphasizing symmetry and clarity, to the earlier Romanesque style.
 a. true
 b. false

30. Gothic architecture was predominantly found in what areas?
 a. urban
 b. rural

31. The *Lindisfarne Gospels* exemplify _____ art.
 a. Celtic-Germanic
 b. Carolingian
 c. Hiberno-Saxon
 d. Ottonian

32. The first masterpiece of the mature or High Gothic style is the cathedral at _____.
 a. Paris
 b. Amiens
 c. Chartres
 d. Salisbury

33. Ottonian Art was centered in _____.
 a. Germany
 b. France
 c. England
 d. Italy

34. One manifestation of the religious enthusiasm which characterized the Romanesque Period from 1095 on was the _____.
 a. Norman Conquests
 b. crusades
 c. expansion of trade routes
 d. revival of commerce

35. The Late phase of Gothic architecture is also referred to as Flamboyant Gothic.
 a. true
 b. false

36. In Romanesque churches, apse, ambulatory, and radiating chapels form a unit known as a(an) _____.
 a. westwork
 b. triforium
 c. pilgrimage choir
 d. arcade

37. In late Gothic painting, we witness a concern for the development of illusory space.
 a. true
 b. false

38. The *Mission of the Apostles* tympanum of Ste. Madeleine, Vezelay, exemplifies the _____style.
 a. Carolingian
 b. Celtic-Germanic
 c. Gothic
 d. Romanesque

39. Aspects of classicism never affected Gothic sculpture.
 a. true
 b. false

40. The period from 600 to 800 A.D. is referred to as the _____.
 a. Romanesque Period
 b. Gothic Period
 c. Golden Age of Ireland
 d. International Style

Discussion Questions:

1. How was an increased awareness of divergent cultures achieved in the Middle Ages?

2. Discuss the rise of distinctive styles of individual artists in Western Europe.

3. How was the cruciform basilica plan of the Early Christians modified throughout the Middle Ages?

4. Compare and contrast the Romanesque and Gothic architectural styles with regard to their social and religious environments.

5. What factors of Medieval culture favored a conceptual, as opposed to a naturalistic, approach to the human figure in art?

6. How would you characterize the types of sources which inform us about various aspects of art during the Middle Ages?

PART THREE:
THE RENAISSANCE THROUGH THE ROCOCO

Introduction Janson, pp. 403-405

1. What three historical developments had far-reaching consequences in the 15th and 16th centuries?

 a.

 b.

 c.

2. How was the self-awareness of the Renaissance different from the consciousness of the Middle Ages?

3. What was the role of the Italian poet Francesco Petrarca (Petrarch) in the origin of the Renaissance?

4. How is the Renaissance responsive to these two significant factors:

 individualism

 humanism

5. Discuss how the aim of the Renaissance was, in Janson's words (p. 405), "not to duplicate the works of antiquity, but to equal and, if possible, to surpass them."

Chapter One:
The Early Renaissance in Italy

Janson, pp. 408-451

In Florence in the early 15th century, a group of artists challenged the prevalent International Style. Their challenge was based on a revival of the classical aesthetic, which, throughout the Middle Ages, always was more dominant in Italy than in Northern Europe. This classical revival, however, was uniquely joined to values derived from a penetrating observation of nature. The Renaissance would grant both art and the artist a new dignity.

1. What role did Leonardo Bruni play in defining the Renaissance in Florence?

2. During the Renaissance, how were the visual arts, previously defined as "mechanical arts," elevated to the status of the liberal arts?

3. How did this new definition of art affect the status of the artist?

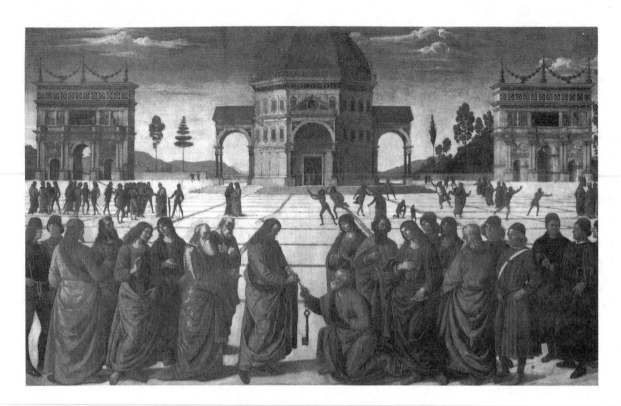

PIETRO PERUGINO, *THE DELIVERY OF THE KEYS.*
1482. Fresco. Sistine Chapel. The Vatican, Rome
(Janson, p. 446, ill. 586)

1. What different types of perspective are used to achieve the spatial illusion in this fresco painting?

2. How is this illusionism bound to Renaissance concerns of naturalism?

3. How does this painting relate a Christian theme to classical antiquity?

1. How do Nanni di Banco's *Quattro Coronati* (Janson, p. 410, ill. 527) unite, in Janson's words, "classical form and content?"

How is this different from Medieval classicism?

2. Cite three ways in which Donatello's *St. Mark* at Or San Michele (Janson, p. 411, ill. 530) re-establishes classical attitudes toward the human body in sculpture?

 a.

 b.

 c.

3. Define *schiacciato*: as exemplified in Donatello's *St. George* relief (Janson, p. 413, ill. 532), how is it different from relief sculpture you have already studied?

4. How does Donatello's *Zuccone* (Janson, p. 413, ill. 533) communicate the psychological and physical realism which distinguished Early Renaissance figurative art?

6. Define linear perspective: how did the architect Filippo Brunelleschi figure in the development of this type of perspective?

7. How was the invention of linear perspective involved in "upgrading" the visual arts to the status of the liberal arts?

8. What elements of perspective are found in Lorenzo Ghiberti's *Gates of Paradise* (Janson, p. 416-418, ills. 538-539)?

Do any traces of the Gothic International Style remain in Ghiberti's work?

9. In the Renaissance rediscovery of the unclothed body in art, what is the difference between "naked" and "nude?" Cite particular examples in developing your answer.

10. What was Filippo Brunelleschi's role in the development of Early Renaissance architecture?

11. Brunelleschi's church of S. Lorenzo (Janson, pp. 419-420, ills. 542-543) is distinguished by a new emphasis on what two qualities?

 a.

 b.

12. How did the classical vocabulary of architecture suit Brunelleschi's abstract "space block" treatment of S. Lorenzo?

13. How are proportions in Renaissance architecture related to the ancient Greek philosopher Pythagoras and, in Renaissance terms, to the science of the universe?

14. How does Masaccio's Renaissance painting, *The Holy Trinity with the Virgin, St. John, and Two Donors* (Janson, p. 423, ill. 551), respond to the following artists and formal element:

 Giotto

 Donatello

 scientific perspective

15. Define "continuous narration;" how is it exemplified in Masaccio's painting *The Tribute Money* (Janson, p. 425, ill. 555)?

16. Discuss the differences between tempera and oil paint.

17. How does Fra Filippo Lippi's *Madonna Enthroned* (Janson, p. 428, ill. 558) carry the influence of Masaccio?

How is it different?

18. Why is Fra Angelico's art, in Janson's words (p. 429), "something of a paradox?"

19. What did Domenico Veneziano introduce to Florentine art when he settled in Florence in 1439?

20. How does the Renaissance fondness for mathematics permeate the paintings of Piero della Franscesca?

21. How does Paolo Uccello treat perspective in unique ways?

Central and Northern Italy: 1450-1500 Janson, pp. 434-451

1. How were the "seeds" of the Renaissance planted in Northern Italy?

2. Leone Battista Alberti, the Renaissance humanist and art theoretician, was also a practicing architect; how did Alberti respond to the influence of antiquity in designing the following buildings:

Palazzo Rucellai, Florence (Janson, p. 434, ill. 566)

S. Francesco, Rimini (Janson, p. 435, ills. 567-568)

S. Andrea, Mantua (Janson, p. 435, ills. 569-571)

3. Alberti's design for S. Andrea introduces us to the "colossal order;" what is meant by the "colossal order" and how does it affect the design of the building?

4. Discuss the iconography of the centrally planned church in the Renaissance.

5. How does Giuliano da Sangallo's Sta. Maria della Carceri, Prato, (Janson, p. 436, ills. 572-574) express Alberti's theoretical ideas on centrally planned churches?

6. Donatello worked in Padua from 1443 to 1453; what was the effect of his absence on the development of sculpture in his native Florence during those years?

7. How does the *Tomb of Leonardo Bruni* (Janson, p. 439, ill. 577), the Florentine statesperson, express the essence of the Renaissance?

8. How was the Renaissance taste for collecting sculpture satisfied by artists like Antonio del Pollaiuolo?

9. What was the role of Andrea del Verocchio in late 15th-century Italian sculpture?

10. Define Neo-Platonism; how is this Renaissance philosophy manifested in works of Sandro Botticelli?

11. How is an attention to realism exemplified in works of these Italian artists:

Piero di Cosimo

Domenico Ghirlandaio

13. How was the Florentine Renaissance style transmitted to Venice in the 15th century?

14. Discuss the artistic contributions of Andrea Mantegna with regard to:

"worm's eye" perspective

humanism

the remains of antiquity

Donatello

15. How is Giovanni Bellini's Venetian painting a response both to "Florentine grandeur" and "Venetian poetic intimacy" (Janson, p. 450)?

Chapter Two:
The High Renaissance in Italy

The High Renaissance in Italy was a brief artistic period; barely twenty years in length, it is one of the shortest defined periods in the history of art. Yet, the High Renaissance witnessed an unprecedented growth of artistic activity, led by the herculean creative powers of Leonardo, Michelangelo, Bramante, Raphael, and Titian. Like the Early Renaissance, the High Renaissance drew from the classical aesthetic, but it sought to surpass the art of antiquity in blending ideality and naturalism.

Janson, pp. 452-481

1. As Janson notes the High Renaissance was both the culmination of the Early Renaissance, while at the same time a departure from it. How do the writings of Giorgio Vasari support this assertion?

2. Define the following terms and discuss how they are applicable to the painting of Leonardo da Vinci:

chiaroscuro (See also Janson, *Introduction*, p. 30)

sfumato

3. How do Leonardo's paintings communicate both a pictorial unity and emotional continuity?

4. Compare and contrast the *Last Supper* of Leonardo (Janson, p. 455, ill. 596) with that of Andrea del Castagno (Janson, p. 433, ill. 564).

5. How do the figures in Leonardo's paintings, through their gestures, reveal the intentions of their souls?

6. In his drawings, what contributions did Leonardo make to:

science

architecture

7. Although small in size, Bramante's Tempietto (Janson, p. 458, ills. 601-602) reflects the grandeur of High Renaissance architecture. How does Bramante achieve this effect?

8. How does Bramante's plan for the new St. Peter's relate to the following:

Alberti's ideas on centrally planned architecture

"sculptured wall" principle

the scale of the Pantheon and that of the Basilica of Constantine

concrete construction

9. How does Michelangelo's *David* (Janson, p. 461, ill. 607) communicate the psychic energy which is a trademark of Michelangelo's art?

10. Define *terribilità*; how does this artistic concept relate to Michelangelo's insistence on following the authority of his own genius?

11. How does the Sistine Chapel Ceiling focus our attention on the human figure as a central theme in High Renaissance art?

12. How does the recent restoration of the Sistine Chapel Ceiling revise our previous views of Michelangelo as a colorist?

13. How does the pessimism of Michelangelo's *Last Judgment* (Janson, p. 466, ill. 614) reflect the spiritual crisis of the Reformation?

14. Michelangelo's sculpture and architecture for the Medici Chapel (Janson, p. 467, ill. 616) were conceived as an ensemble; discuss how this unity is demonstrated in the integration of sculpture with architecture.

MICHELANGELO,
Vestibule of the Laurentian Library.
Florence. Begun 1524;
stairway designed 1558-59.
(Janson, p. 468, ill. 617)

15. In the vestibule of the Laurentian Library, Michelangelo, using the classical vocabulary of architecture, created a new aesthetic. List four ways in which Michelangelo deviated from the classical aesthetic:

a.

b.

c.

d.

16. What does the use of the "colossal order" contribute to Michelangelo's design for the Campidoglio (Janson, pp. 469-470, ills. 619-621) and St. Peter's (Janson, pp. 470-471, ills. 622-624)?

17. Michelangelo's art centered on the human figure. Even his architectural designs were seen to have an organic quality. How do Michelangelo's architectural designs achieve an almost "muscular" vitality?

18. When Michelangelo became architect of St. Peter's, how did he respond to Bramante's original plan?

19. How do the paintings of Raphael (and his shop) demonstrate his unique creative power to synthesize qualities of Leonardo and Michelangelo?

20. Cite four ways in which Raphael's *School of Athens* (Janson, p. 473, ill. 627) may be viewed as the perfect example of High Renaissance art.

a.

b

c.

d.

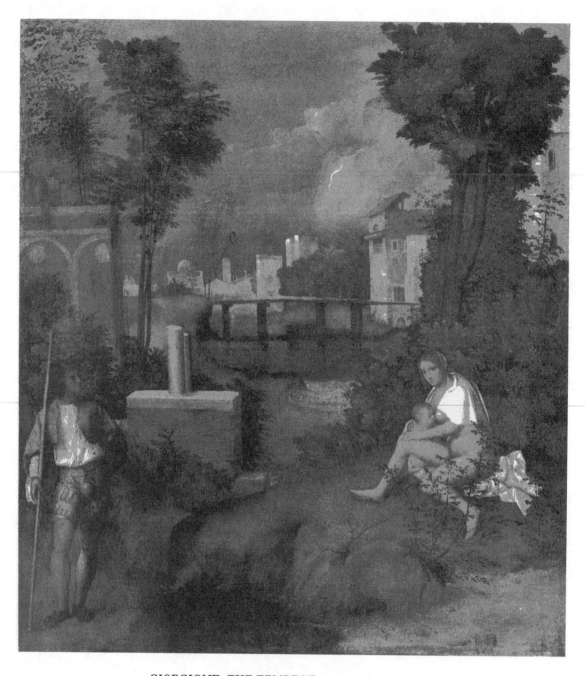

GIORGIONE, *THE TEMPEST*. c. 1505. Oil on canvas.
31 1/4 x 28 3/4." Galleria dell'Accademia, Venice
(Janson, p. 476, ill. 631)

21. Giorgione's *Tempest* has defied attempts at precise iconographic interpretation. How does the mood of this painting support the interpretation that the work "represents Adam and Eve after the Fall" (Janson, p. 476)?

22. What does Giorgione's *Tempest* introduce into the realm of painting?

23. How did Titian fully realize the potential of color in the medium of oil paint?

24. What formal qualities display the introspection of Titian's late work?

Chapter Three:
Mannerism and Other Trends

The 16th century in Italian art was particularly rich in its diversity. Following the High Renaissance, Mannerist artists deliberately created artificial and complex compositions as a demonstration of their intellectual and technical virtuosity. The impact of the Counter-Reformation is associated with the Proto-Baroque style, which contained the seeds of 17th-century Italian Baroque art. Another stylistic trend, displaying an interest in realism, was apparent in North Italy. One of the most significant developments for artists in the 16th century was the creation of art academies; the first art academy opened in Florence in 1563.

Janson, pp. 482-503

1. How would you characterize the period from 1525 to 1600 in Italian art?

Painting Janson, pp. 483-496

1. How has the definition of Mannerism remained problematic through time?

2. How is the "subjective latitude of Mannerism" (Janson, p. 483) exemplified in the works of Rosso Fiorentino and Pontormo on one hand, and in the work of Parmigianino on the other?

3. Define etching; what are the qualities of this medium of printmaking?

4. Cite three ways in which the composition of Tintoretto's *Last Supper* (Janson, p. 490, ill. 647) may be considered Mannerist:

 a.

 b.

 c.

How did this type of composition serve the intent of the artist?

5. How is the art of El Greco a unique synthesis of Titian, Tintoretto, Raphael, Michelangelo, and attitudes of the Counter-Reformation?

6. Yet another style in Italian painting, particularly in the North, communicated a strong interest in everyday reality. How is this interest evidenced in Paolo Veronese's *Christ in the House of Levi* (Janson, p. 494, ill. 653)?

How does this painting act as a cultural document of the Counter-Reformation?

7. Another trend in Italian art, parallel with Mannerism, is termed Proto-Baroque. How is this style different from Mannerism, and what artists exemplify the Proto-Baroque ?

Sculpture Janson, pp. 496-498

1. How do the sculptures of Alonso Berruguete (Janson, p. 496, ill. 656) and Benvenuto Cellini (Janson, p. 497, ill. 657) represent different aspects of Mannerism?

2. How is the Mannerist sculpture of Giovanni Bologna (Janson, p. 498, ill. 659) more concerned with a display of technical skill than with iconography?

Architecture Janson, pp. 498-503

1. What questions are involved in the definition of Mannerist architecture?

How do the designs of Giorgio Vasari and Bartolommeo Ammanati relate to this definition?

2. How may the buildings designed by Andrea Palladio be referred to as "classicistic" and Mannerist?

3. How are the concerns of the Counter-Reformation reflected in Giacomo Vignola's plan for Il Gesù (Janson, p. 502, ill. 668)?

How is the integration of light an important factor in our experience of this church?

4. The facade of Il Gesù by Giacomo della Porta (Janson, p. 503, ill. 670) is considered a prototype for later Baroque architecture; how would you support this statement?

Summary of Italian and European Art, 1525-1600

To assist our understanding of the varied developments in 16th-century Italian art, provide, in the chart below, artists, exemplary works, and formal characteristics of the different styles and media.

	ARTISTS	WORKS	CHARACTERISTICS
MANNERISM			
Painting	_____	_____	_____
Sculpture	_____	_____	_____
Architecture	_____	_____	_____
PROTO-BAROQUE			
Painting	_____	_____	_____
Architecture	_____	_____	_____
REALISM			
Painting	_____	_____	_____

Chapter Four: "Late Gothic" Painting, Sculpture, and the Graphic Arts

The transition to the Renaissance in the cosmopolitan centers of Flanders, which included Bruges, Ghent, and Tournai, was a gradual one. Although the cultural growth of Flanders was rich and varied, Flemish artists were not as strongly attached to the revival of classical antiquity as were their Florentine counterparts. Throughout the century in Northern Europe, architecture and other art forms continued to reflect the late Medieval aesthetic; only in painting were late Medieval attitudes joined to new formal considerations. In the latter half of the century, printmaking revolutionized visual communication.

Janson, pp. 504-525

Renaissance Versus "Late Gothic" Painting Janson, pp. 504-520

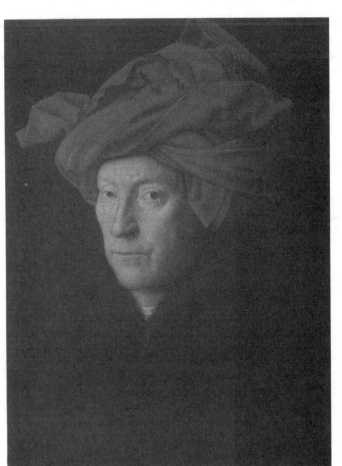

JAN VAN EYCK, *MAN IN A RED TURBAN* (SELF-PORTRAIT?)
1433. Oil on panel, 10 1/4 x 7 1/2." The National Gallery.
London. Reproduced by courtesy of the Trustees.
(Janson, p. 510, ill. 676)

This painting is believed to be a self-portrait of the innovative Flemish artist Jan van Eyck. The first six questions below pertain to this work; they will direct our understanding of 15th-century Northern European painting.

1. The medium of this painting is oil; how did a new technique of oil painting used in Flanders in the early 15th century revolutionize painting?

2. How do the following terms relate to this new technique of oil painting:

glazes

impasto

3. How are the effects achieved in this work different from those accomplished with tempera paint?

4. How is the uncompromising realism of this work exemplary of early 15th-century Flemish painting?

5. How is this (probable) self-portrait related to new attitudes toward, and promoted by, 15th-century artists?

6. Compare and contrast this portrait with Rogier van der Weyden's *Francesco d'Este* (Janson, p. 514, ill. 681).

Please return to Janson, p. 504, as you begin to answer the rest of the study questions for this chapter.

7. What problems are there in defining the beginning of Renaissance painting, and how do these questions involve Giotto and Boccaccio?

8. The Renaissance began in two cosmopolitan centers about 1420; these centers are:

a.

b.

9. Why is the term "Late Gothic" used to designate 15th-Century Northern painting?

How is this style similar to, while at the same time different from, the International Style?

10. How are these differences from the International Style exemplified in the Master of Flémalle's *Merode Altarpiece* (Janson, p. 505, ill. 671)?

11. Define "disguised symbolism;" what was its purpose and how is it used in the *Merode Altarpiece*?

12. What were the roles of Jan and Hubert van Eyck in the development of "Late Gothic" painting?

13. Define "atmospheric perspective;" how was this formal element utilized in the work of Jan and Hubert van Eyck?

14. What is a triptych?

15. Janson (p. 509), describes the *Ghent Altarpiece* as "the greatest monument of early Flemish painting." How would you support this assertion?

16. How does Rogier van der Weyden's *Descent from the Cross* (Janson, p. 512, ill. 679) fuse the new formal elements of 15th-century painting with the emotional drama of late Medieval art?

17. What qualities of Hugo van der Goes' *Portinari Altarpiece* (Janson, p. 514, ill 682) aroused Italian artists after the work arrived in Florence in 1483?

18. What elements of Hieronymus Bosch's *Garden of Delights* (Janson, pp. 516-517, ills. 684-685) are typical of Northern 15th-century painting?

What elements are unique to the works of Bosch?

19. How does Bosch fuse pictorial fantasy and reality to communicate his enigmatic content?

20. Discuss the influence of Flemish painting after 1430 on the following masters of Swiss, German and French art:

Conrad Witz

Jean Fouquet

Enguerrand Quarton

"Late Gothic" Sculpture Janson, pp. 521-523

1. How do the new standards of Northern panel painting influence 15th-century sculpture, especially the work of Michael Pacher?

1. How is the history of printmaking tied to developments in the Ancient Near East and China?

2. What was the impact of printed books and illustrations on Western Civilization?

3. How were prints used in the 15th century?

4. Describe the following printmaking processes and note examples of each:

 woodcut

 engraving

 drypoint

 etching

5. What formal qualities and inventive elements distinguish the prints of Martin Schongauer (Janson, p. 523, ill. 694)?

Chapter Five:
The Renaissance in the North

After 1500, the influence of the Italian Renaissance began to replace the "Late Gothic" stylistic tendencies of Northern European art. As the Italian influence was itself diverse, it spurred a variety of artistic developments. Northern painting, however, retained a strict naturalism, which distinguished it from the idealization of Italian art.

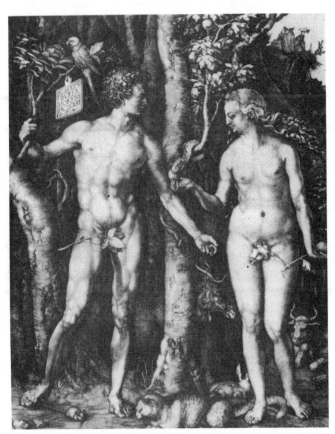

Janson, pp. 526-547

ALBRECHT DURER. *ADAM AND EVE.1504*
Engraving, 9 7/8 x 7 5/8"
Museum of Fine Arts, Boston
(Janson, p. 531, ill. 702)

1. How does this engraving by Albrecht Dürer join the Northern pictorial tradition with Italian Renaissance attitudes toward the figure?

2. How does the iconography of this print relate to classical mythology?

3. How are the figures of Adam and Eve conceived; are they drawn from life or are they constructed according to a set of mathematical principles?

4. Why did this artist, Albrecht Dürer, incorporate aspects of Italian art into his work?

5. Albrecht Dürer was involved in changing the status of the artist in Northern Europe in the 16th century; how did he achieve this?

Please return to Janson, p. 526, as the following questions will continue our study of Northern Renaissance art.

6. When did the influence of Italian art reach Northern Europe?

7. How would you describe this Italian influence: is it singular or varied in its sources?

1. The two masters of German High Renaissance painting were:

 a.

 b.

2. How would you characterize the union of reality and symbolism in Matthais Grünewald's *Crucifixion* from the *Isenheim Altarpiece* (Janson, p. 526 ill. 696)?

3. Iconographically and formally, how is the first stage view of the *Isenheim Altarpiece* different from the second view (Janson, p. 527, ill. 697)?

4. How did the Renaissance affect the art of Grünewald?

5. In what ways did Albrecht Dürer advance the print medium to a "fully matured graphic style" (Janson, p. 530)?

6. In what ways was Dürer's art related to Northern Protestantism?

7. Albrecht Altdorfer's *Battle of Issus* (Janson, p. 534, ill. 707) elevates this human battle to a cosmic level; how does the painting achieve this?

8. How is Baldering Grien's fascination with the "magical and the demonic" (Janson, p. 536) exemplified in his work?

9. What contributions to portraiture were made by Hans Holbein the Younger?

How did Holbein's travels affect the development of his art?

10. How would you assess the varying degrees of influence by Holbein on French and English portraiture?

1. Describe how the turbulent history and independence of the Netherlands affected the development of art there.

2. What two concerns characterize 16th-century Netherlandish painting?

 a.

 b.

3. Who were the "Romanists," and what did they bring to Netherlandish art in the sixteenth century?

4. Discuss the origins of landscape and still life painting in the Netherlands.

What artists pioneered these developments?

5. How did Peter Brueghel the Elder, in his paintings of landscape and peasant life, communicate attitudes of Netherlandish culture?

1. How would you characterize the assimilation of the Italian Renaissance architectural style in France after the 1520's?

Was this assimilation complete, or was it fused with latent Medieval attitudes?

2. In the design for the new Louvre, how did Pierre Lescot synthesize, in Janson's words (p. 546), "the traditional château with the Renaissance palazzo?"

3. How may Jean Goujon be considered a Mannerist sculptor?

Chapter Six:
The Baroque in Italy and Spain

Janson, pp.548-573

The term Baroque does not imply a single, unified art style. The exuberant and dynamic visual effects which we usually associate with the Baroque are paralleled by a Baroque classicism. Like previous art styles, the Baroque will develop regional characteristics. Spanish artists adapted aspects of Baroque naturalism to their own cultural identity. Baroque art was capable of appealing to auto-cratic rulers, the Counter-Reformation Church, and lavish patrons.

1. Cite two paradoxes which we encounter when we define Baroque Art as a style only expressing the spirit of the Counter-Reformation:

 a.

 b.

2. May we consider Baroque Art politically as the "style of absolutism?"

3. Does Baroque Art directly reflect the new science and philosophy of the period?

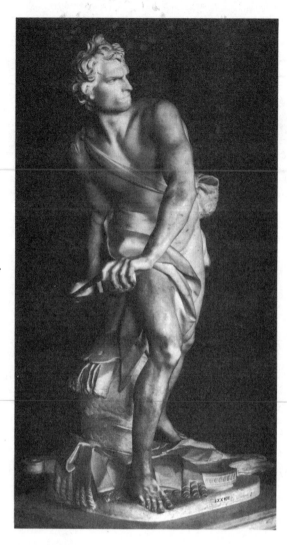

GIANLORENZO BERNINI. *DAVID*.
1623. Marble, lifesize.
Galleria Borghese, Rome
(Janson, p. 565, ill. 752)

1. Janson (pp. 564-565) establishes a stylistic relationship between Hellenistic and Baroque sculpture. What similarities are there between these styles?

2. How does Bernini's sculpture deal in a new way with both space and illusion?

3. How is the naturalism of this figure characteristic of the Baroque style?

4. How does Bernini's interpretation of David, viewed at the moment of greatest action, compare with earlier sculptures of the same subject (see Janson, p. 415, ill. 535 and p. 461, ill. 607)?

How is Bernini's interpretation exemplary of Baroque art?

Painting in Italy Janson, pp. 549-560

1. How did Caravaggio's naturalism communicate a "lay Christianity?"

2. What factors restrained women artists from doing narrative subjects from the 17th to the 19th centuries?

3. Artemisia Gentileschi transcended the above discussed limitations; how did she accomplish this?

4. How does Annibale Carracci's ceiling fresco for the Palazzo Farnese (Janson, pp. 553-554, ills. 729-730) create a synthetic balance of classicism and naturalism?

5. Discuss the concept of the "ideal landscape" in the work of Annibale Carracci.

6. Define the contributions of the following artists to Baroque illusionistic ceiling painting:

Guido Reni

Guercino

Pietro da Cortona

Architecture in Italy
Janson, pp. 560-564

1. How does Carlo Maderno's facade for the new St. Peter's draw inspiration from Michelangelo and Giacomo della Porta?

How is it different?

2. How is Bernini's *Tabernacle* in St. Peter's (Janson, p. 561, ill. 740) expressive of both Baroque energy and Christian iconography?

3. In what ways are the energetic architectural rhythms of Francesco Borromini unique to Baroque architecture?

4. Janson, p. 563, asserts that Guarino Guarini was Borromini's "most brilliant successor;" how are Guarini's works in Turin viewed in this tradition?

Sculpture in Italy
Janson, pp. 564-5C8

1. How did Bernini combine different media to create his "visionary experience" of the *Ecstasy of St. Theresa* (Janson, pp. 566-567, ills. 753-754)?

2. How does Allessandro Algardi's "new kind of high relief" (Janson, p. 567) support the Baroque experience of his sculpture?

Painting in Spain

Janson, pp. 569-573

1. How do the still life paintings of Sanchez Cotán differ from Northern still life paintings?

2. The paintings of Diego Velázquez examine the optical mysteries of the world; how do his paintings communicate these visual effects?

3. How is a Spanish temperament of "ascetic piety" communicated in Francisco de Zurbarán's *St. Serapion* (Janson, p. 573, ill. 760)?

4. What artists influenced the work of Murillo?

How does his work retain an "unmistakable Spanish character" (Janson, p. 573)?

Chapter Seven:
The Baroque in Flanders and Holland

We continue to witness the diversity of Baroque art as we look to Flanders and Holland. Flemish artists wed Italian influences with Northern natural- ism, while Dutch Baroque art, which is limited to paint- ing, reflects the new freedom, tolerance, and mercantile society of the Nether- lands in the 17th century. The most remarkable Dutch painter, Rembrandt, displayed affinities with the broader range of Baroque art.

Janson, pp. 574-593

Flanders

Janson, pp. 574-580

1. How did Peter Paul Rubens accomplish, in Janson's words (p. 574), "the breakdown of the artistic barriers between North and South?"

2. How is this artistic fusion realized in the following works by Rubens:

Raising of the Cross (Janson, p. 575, ill. 762)

The Garden of Love (Janson, pp. 577, ill. 764)

3. What was the contribution of Anthony van Dyck to 17th-century portraiture?

4. How was the impact of Rubens felt by the following artists:

Jacob Jordaens

Jan Brueghel

Frans Snyders

1. What factors led to the significance of the private art collector in 17th-century Holland (see Janson, p. 574)?

2. How did the private art collector support the production of works of art "for the market" (see Janson, p. 574)?

3. What were the advantages and disadvantages to this new market in art(see Janson, p. 574)?

(Please return to p. 581.)

4. How was the Utrecht School important for the transmission of the Baroque style to Holland?

5. How do the portraits of Frans Hals combine a technical skill with a penetrating insight into the character of the sitters?

6. What were Judith Leyster's contributions to Dutch genre painting?

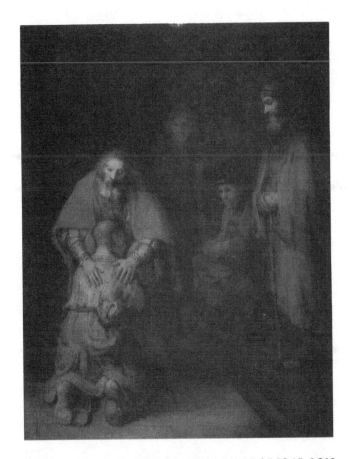

REMBRANDT, *THE RETURN OF THE PRODIGAL SON*
c. 1665. Oil on Canvas, 8' 8" x 6' 7 3/4"
Hermitage Museum, Leningrad
(Janson, p. 585, ill. 780)

7. How does Rembrandt's work reflect an indirect contact with Caravaggio?

8. In what ways is *The Return of the Prodigal Son* exemplary of Rembrandt's "self-analytical approach" (Janson, p. 584) to painting?

9. Rembrandt's *The Night Watch* (Janson, p. 584, ill. 777) is unique as a Baroque group portrait; what formal elements make it so?

10. Discuss Rembrandt's contributions as a printmaker.

11. How did landscape and still life painting fit into the new art market in Holland?

12. Discuss the varied approaches to landscape painting in the works of:

Jan van Goyen

Aelbert Cuyp

Jacob van Ruisdael

13. How are the works of Rachel Ruysch exemplary of Dutch still life paintings?

14. Define genre painting; how is it exemplified in the work of:

Jan Steen

Jan Vermeer

15. How is light an "active element" (Janson, p. 593) in the paintings of Vermeer?

Chapter Eight:
The Baroque in France and England

Janson, pp. 594-609

Throughout the 17th century, France grew in size, wealth, and political importance. Baroque classicism was especially appropriate to the designs of the French monarchy. England was also affected by Baroque classicism, yet some English artists retained an air of informality about their work. In Paris (1648) and later in London (1768), art academies preached an increasingly conservative dogmatism.

France

Janson, pp. 594-607

1. What is meant by the style of Louis XIV?

Why is it referred to as Baroque Classicism?

2. What two traditions nourished this official French "classic" court style?

 a.

 b.

3. In what ways do Jacques Callot's prints relate past artistic traditions to contemporary events?

4. How do the paintings of Georges de La Tour reflect the influence of Caravaggio?

5. How do Louis Le Nain's genre paintings relate to their counterparts in Netherlandish art?

6. What "classical" values are apparent in the works of Nicolas Poussin?

7. How did Poussin associate painting with literature?

8. How are the paintings of Claude Lorraine and Simon Vorret different from those of Poussin?

9. What was the role of the Royal Academy of Painting and Sculpture, which opened in Paris in 1648, in the art life of France?

10. What were the roles of François Mansart and Jean Baptiste Colbert in the development of Baroque classicism in architecture?

11. How does this style of Baroque classicism reflect the authority of Louis XIV, especially in the Palace and Garden of Versailles?

12. How does Jules Hardouin-Mansart's Church of the Invalides (Janson, p. 605, ills. 804-805) **betray the influence of:**

 a. Michelangelo's architectural designs

 b. Maderno

How is the design of the dome original to Hardouin-Mansart?

13. What was the impact of Bernini's brief stay in France (1665) on sculpture and **architecture,** particularly the works of:

Antoine Coysevox

Pierre-Paul Puget

1. How does the architecture of Inigo Jones reflect the influence of Palladio?

2. Sir Christopher Wren was both a scientist and an architect. How did he incorporate his understanding of French and Italian architecture into his design for St. Paul's Cathedral, London (Janson, pp. 608-609, ills. 810-812)?

3. How does the concept of eclecticism apply to architecture designed by Sir John Vanbrugh?

Chapter Nine: The Rococo

The Rococo style dominated the visual arts from the early to mid-eighteenth century. Both similar to yet different from previous Baroque styles, the term Rococo was first used to designate a style of French art; its light, decorative elegance complemented the artificiality of aristo-cratic values and tastes.

France

Janson, pp. 610-616

1. What is the relationship of the Rococo style to Louis XV?

2. Rococo art is both similar to, and yet different from, Baroque Art. How would you explain this statement?

3. Describe the role of the decorative arts in defining the Rococo style.

4. How is the influence of Bernini transformed in the works of:

Clodion

Jean-Baptiste Pigalle

5. How would you characterize the "Poussinistes"/ "Rubénistes" academic controversy?

6. Define *fêtes galantes*; how does this concept apply to the work of Jean-Antoine Watteau?

7. What qualities of Rococo art are emphasized in the works of:

 François Boucher

 Jean Honoré Fragonard

8. How are the paintings of Jean-Baptiste Siméon Chardin atypical of Rococo art?

9. What aspects of Marie-Louise Elisabeth Vigée-Lebrun's portraits exemplify Rococo portraiture?

England Janson, pp. 616-621

1. William Hogarth's series of paintings and prints, which he described as "modern moral sub-jects," commented on what aspects of human nature and contemporary English society?

2. How did an ability as a portrait artist affect the livelihood of English painters?

3. What stylistic components are found in a portrait by Thomas Gainsborough?

The portrait reproduced below is by Sir Joshua Reynolds, the first president of London's Royal Academy in 1768.

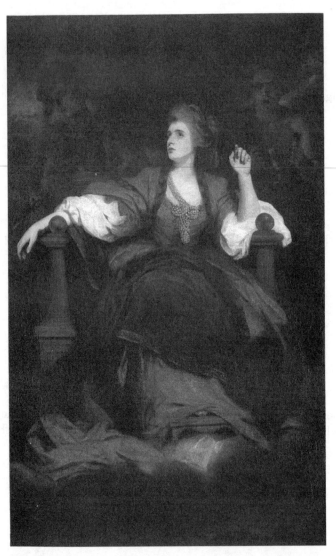

SIR JOSHUA REYNOLDS. *MRS. SIDDONS AS THE TRAGIC MUSE.* 1784.
Oil on canvas, 93 x 57 1/2."
Henry E. Huntington Library and Art Gallery
San Marino, California (Janson, p. 619, ill. 828)

4. In terms of the art academy, what elements of this painting elevate it to the "grand style?"

How does Reynolds' approach differ from Gainsborough's portrait of the same well-known actress (refer to question 3)?

5. How did Louis-François Roubiliac join the Baroque sculptural tradition with a peculiarly English informality?

Germany and Austria Janson, pp. 621-625

1. Which Baroque architectural style set the foundation for Rococo architecture in Austria and southern Germany?

How was this Baroque architectural style transmitted north of the Alps?

2. Describe the Rococo architectural features found in buildings designed by:

Fischer von Erlach

Jakob Prandtauer

Balthasar Neumann

Dominikus Zimmermann

Italy Janson, pp. 625-629

1. How do the paintings of Giovanni Battista Tiepolo relate to the tradition of Baroque illusionistic ceiling painting?

2. Define *veduta*; how's this type of painting exemplified in the works of Canaletto?

144

As with the introductory sections of the two previous SELF-REVIEWS, you will be asked to reason from formal and iconographic evidence presented in two works of art which, most probably, are not known to you. The questions will guide your approach to the paintings.

1.

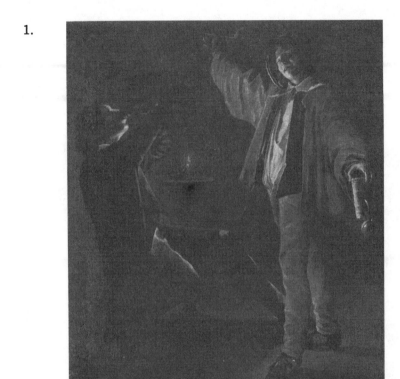

Period and Style: Approximate Date: Type of Painting:

_____ _____ _____

a. What is the subject of this painting; what do we call paintings which display these everyday subjects?

b. Where and when was this type of painting especially popular?

c. What artists which you have studied have treated similar themes in this manner?

d. What conclusions can you draw with regard to period, style, approximate date, and artist?

 2.

Period and Style: Approximate Date: Type of Painting:

_____ _____ _____

a. This is a _____ painting (refer to subject matter).

b. This type of painting was popular during the _____Period, particularly in
_____.

c. Were there any moral associations made with this type of painting? If so, how?

d. What artists were especially proficient at this type of painting?

e. How is the style of this work a clue to the nationality of its artist?

f. What conclusions can you reach regarding period, style, approximate date, probable artist, and purpose?

As with your previous SELF-REVIEW learning guides, the following forty multiple-choice and true/false questions will examine your grasp and understanding of the content of PART III.

1. The aim of the Renaissance was not to duplicate the works of antiquity, but to equal and, if possible, to surpass them.
 a. true
 b. false

2. The concept of the Renaissance was influenced in the 1330s by the writings of _____.
 a. Leonardo Bruni
 b. Boccaccio
 c. Giotto
 d. Francesco Petrarca

3. _____ began, in the 17th century, the major role of women artists.
 a. Judith Leyster
 b. Marie-Louise Elisabeth Vigée-Lebrun
 c. Sofonisba Anguissola
 d. Artemisia Gentileschi

4. Leonardo da Vinci's *Last Supper* exemplifies the artist's aim that the painting depict, through figurative gestures and movements, the intention of the soul.
 a. true
 b. false

5. The architect who began the rebuilding of St. Peter's in Rome was _____.
 a. Bernini
 b. Bramante
 c. Michelangelo
 d. Borromini

6. The original plan for the new St. Peter's was a _____.
 a. cruciform basilica
 b. central plan (based on the circle and square)

7. The Greek Mannerist painter who absorbed Italian influences before settling in Spain was
 _____.
 a. Tintoretto
 b. Veronese
 c. El Greco
 d. Berruguete

8. The Northern Italian architect whose buildings and writings would prove influential to later generations of architects was _____.
 a. Giorgio Vasari
 b. Andrea Palladio
 c. Giacomo Vignola
 d. Bernini

9. The Northern Renaissance artist who refined and popularized the media of woodcut and engraving was _____.
 a. Matthias Grünewald
 b. Martin Schongauer
 c. Albrecht Dürer

10. Which of the following paintings displays a wealth of "disguised symbolism:"
 a. *The Battle of Issus* by Altdorfer
 b. *Still Life* by Cotan
 c. *The Merode Altarpiece* by the Master of Flémalle
 d. *Mrs. Siddons* by Gainsborough

11. The architect who invented scientific perspective and re-invested the classical aesthetic in early 15th-century Italian architecture was _____.
 a. Alberti
 b. Bramante
 c. Michelozzo
 d. Brunelleschi

12. The English artist and academician who promoted the "grand style" in painting was _____.
 a. Gainsborough
 b. Hogarth
 c. Reynolds
 d. Jones

13. The artists who contributed to the development of the new technique of oil painting, and who created the *Ghent Altarpiece*, were (choose two):
 a. Jan van Eyck
 b. Rogier van der Weyden
 c. Hugo van der Goes
 d. Hubert van Eyck

14. The Northern "Late Gothic" artist who combined a seemingly irrational visual fantasy with reality to communicate a stern moralizing content was _____.
 a. Witz
 b. Quarton
 c. Weyden
 d. Bosch

15. A medium of printmaking in which V-shaped grooves are cut into a metal plate is termed _____.
 a. woodcut
 b. engraving
 c. etching

16. The Italian artist who did more to re-establish classical attitudes toward the human body in early 15th-century Florence was _____.
 a. Nanni di Banco
 b. Ghiberti
 c. Pollaiuolo
 d. Donatello

17. The proportional concerns of Italian Renaissance aesthetics ultimately derive from the Greek philosopher Pythagoras.
 a. true
 b. false

18. The painting which is viewed as the perfect embodiment of the classical spirit of the Italian High Renaissance is the _____.
 a. *School of Athens* by Raphael
 b. *Mona Lisa* by Leonardo
 c. *Sistine Chapel Ceiling* by Michelangelo
 d. *Tempest* by Giorgione

19. The Proto-Baroque style of 16th-century Italian art was exemplified by _____.
 a. Pontormo
 b. Veronese
 c. Parmigianino
 d. Correggio

20. The French Rococo artist whose work is atypical of the period, and who invested a dignity in commonplace events and objects, was _____.
 a. Fragonard
 b. Chardin
 c. Watteau
 d. Boffrand

21. The Spanish artist who explored the optical mysteries of light and its effect on form and color was _____.
 a. El Greco
 b. Velázquez
 c. Zurbarán
 d. Cotán

22. The Dutch Baroque artist whose paintings and prints were characterized by innovation and introspection was _____.
 a. Rembrandt
 b. Hals
 c. Ruisdael
 d. Terbrugghen

23. The formal element of perspective which is fundamental to our perception of deep space is "atmospheric perspective."
 a. true
 b. false

24. The Flemish Baroque artist, also respected as a political advisor and emissary, who energetically synthesized the Northern and Italian artistic traditions was _____.
 a. Van Dyck
 b. Van Eyck
 c. Campin
 d. Rubens

25. One reason for the birth of the Renaissance in Florence and in the cities of Flanders is that these locations were centers of international banking and manufacturing.
 a. true
 b. false

26. The early 15th-century Florentine painter who joined the influence of Giotto with the renewed interest in naturalism and perspective was _____.
 a. Ghiberti
 b. Veneziano
 c. Fra Angelico
 d. Masaccio

27. Columns which span two or more stories of a building, and so help to unify the design, are known as the "colossal" order.
 a. true
 b. false

28. The first free-standing and life-size nude statue which was completed since antiquity was Michelangelo's *David* of 1501-4.
 a. true
 b. false

29. The Italian artist whose work bears the influence of renaissance Neo-Platonism is _____.
 a. Piero della Francesca
 b. Verrocchio
 c. Perugino
 d. Botticelli

30. The artist who dominated Venetian painting in the first half of the 16th century and who brought a new and full maturity to techniques of oil painting was _____.
 a. Mantegna
 b. Bellini
 c. Giorgione
 d. Titian

31. Translucent films of oil paint are called impasto layers.
 a. true
 b. false

32. The artist who was seen by his contemporaries as possessing *terribilità*, a sublime creative talent, was _____.
 a. Titian
 b. Raphael
 c. Michelangelo
 d. Leonardo

33. Giovanni Bologna's Mannerist sculpture, *The Rape of the Sabine Women*, was primarily conceived as a virtuoso piece by the artist, and not simply to exhibit the classical theme.
 a. true
 b. false

34. The Netherlandish Renaissance painter who explored landscape and peasant life with an acutely observing eye was _____.
 a. Aertsen
 b. Vermeer
 c. Bosch
 d. Pieter Bruegel the Elder

35. Although begun during the High Renaissance, much of the interior decoration of St. Peter's reflects the artificial elegance of Mannerism.
 a. true
 b. false

36. The innovative Italian architect, and rival of Bernini, who brought an extravagant and "elastic" complexity to his designs was _____.
 a. Borromini
 b. Guarini
 c. Maderno
 d. Vasari

37. The Northern Italian artist whose dramatic naturalism contributed to the origin of the Baroque style in Rome in the closing decade of the 16th century was _____.
 a. Guido Reni
 b. Annibale Carracci
 c. Caravaggio
 d. Pietro da Cortona

38. Bernini's *Ecstasy of St. Theresa* combines different media in a unified presentation which has a "theatrical" impact on us.
 a. true
 b. false

39. The greatest and most influential of the French Baroque classicists was _____.
 a. Poussin
 b. Mansart
 c. De La Tour
 d. Lorraine

40. The Royal Academy of Painting and Sculpture, founded in Paris in 1648, exerted little, if any, influence on French art.
 a. true
 b. false

Discussion Questions:

1. In what ways do both the Renaissance and Baroque styles partake of classical attitudes toward art?

2. How did the rise of Art Academies affect the education and status of the artist?

3. Did the Renaissance manage to surpass antiquity?

4. Discuss the concepts of naturalism and ideality in Renaissance and Baroque art.

5. How does Renaissance and Baroque art respond to a varied and developing group of art patrons?

6. In the section of primary sources for Part Three are numerous selections from writings by artists on art. How are these sources different from other primary sources, what forms do they take, and what views do they express?

PART FOUR : THE MODERN WORLD

Janson, pp. 651-655

1. What two kinds of revolutions, which remain ongoing, began our modern era?

 a.

 b.

2. How has the impact of these revolutions affected modern civilization?

3. What is the difference between modernity and modernism?

4. Why do we speak of Modern Art in terms of movements rather than countries or broad art historical periods?

Chapter One:
Neoclassicism and Romanticism

Neoclassicism

Janson, pp. 658-717

The Neoclassical style of the mid-18th century, spurred on by an awakening interest in classical antiquity, was well suited to the political changes which set the foundation for our modern era. Promoted by the major academies of Europe, Neoclassical attitudes affected many aspects of public and private art. Neoclassicism continued into the 19th century, when it was challenged by Romanticism, which, in its distrust of rationalism, opened a new spontaneity of individual expression. In different ways, however, Romanticism also partook of the historicisms which were shared by Neoclassicism. The complex relationship between these styles is a reflection of the social and cultural contrasts, dramatic political changes, and scientific and technological advances of this period. Among these advances was the invention of photography.

JACQUES-LOUIS DAVID. *THE DEATH OF SOCRATES.* 1787.
Oil on canvas, 51 x 77 1/4."
The Metropolitan Museum of Art, New York. Wolfe Fund, 1931.
Catherine Lorillard Wolfe Collection
(Janson, p. 660, ill. 843)

THÉODORE GÉRICAULT. *THE RAFT OF THE "MEDUSA."*
1818-19. Oil on canvas, 16' 1" x 23' 6." Musée du Louvre, Paris
(Janson, p. 677, ill. 868)

The first six questions will reinforce your conceptual understanding as you compare and contrast these paintings by David and Géricault.

1. In what formal and iconographic ways is David's painting exemplary of Neoclassicism?

2. How may Géricault's painting be considered a Romantic work in the Neo-Baroque style?

3. Do these two paintings share any formal qualities?

4. Define Neoclassicism:

5. Define Romanticism (see also Janson, p. 672):

6. How are Neoclassicism and Romanticism both distinct and yet simultaneously interrelated?

In what ways are these art movements related to contemporary philosophical and literary achievements?

Please return to Janson, p. 658, as we proceed with our study of this chapter.

7. In the 18th century, how was classical antiquity linked with a belief in rule by reason?

8. What art historian was most influential in the formation of the Neoclassical aesthetic?

1. How does Jean-Baptiste Greuze's *The Village Bride* (Janson, p. 659, ill. 842) differ from Rococo Art?

2. Describe Jacques-Louis David's artistic and political involvement with the French Revolution.

3. How did *The Death of General Wolfe* (Janson, p. 662, ill. 845), by the American artist Benjamin West, challenge the academic definition of history painting in "the grand manner?"

4. Describe the moral allegorical content of John Singleton Copley's *Watson and the Shark* (Janson, p. 662, ill. 846).

What does the content of Copley's painting share with Neoclassical attitudes toward iconography?

5. How did the career and works of Angelica Kauffman contribute to Neoclassicism while advancing the recognition of women in the arts?

6. The painter George Stubbs brought a new interpretation of the struggle of animal life in nature to his work. What was novel about his approach to this theme?

7. What is meant by the concept of the "picturesque?" How does this concept apply to 18th and 19th-century painting and to the development of the "English landscape garden?"

8. Describe Alexander Cozen's unique approach to landscape compositions.

Sculpture Janson, pp. 664-667

1. How does the history of Neoclassical sculpture differ from that of painting?

2. Jean Antoine Houdin's figurative sculpture joined Neoclassical attitudes with an "acute sense of individual character" (Janson, p. 665); how do Houdin's works achieve this union?

1. What was the influence of Palladio's architectural designs in England, the birthplace of Neoclassicism?

2. What were the characteristics of the English landscape garden?

How did it act as "a vehicle of romantic emotion" (Janson, p. 668)?

3. Jacques-Germain Soufflot's Pantheon was the first significant Neoclassical monument in Paris. How would you describe the Neoclassical features of the building?

What influence from the Gothic style is apparent?

4. How would you characterize Etienne-Louis Boullée and Claude-Nicolas Ledoux as visionary architects?

5. How did the excavations at Herculaneum and Pompeii affect late 18th-century interior decoration, especially the designs of Robert Adam?

6. What was the importance of Thomas Jefferson in fostering Neoclassical architecture in the U.S.?

The Romantic Movement in Painting

Janson, pp. 672-698

1. Why, among the different media of the visual arts, was painting considered the "greatest creative achievement of Romanticism" (Janson, p. 672)?

2. In what formal and iconographic ways does Francisco Goya's Neo-Baroque style announce the arrival of Romanticism?

3. Define Primitif style; how is it related both to Neoclassicism and Romanticism?

4. How did the works of Antoine-Jean Gros provide a transition from the Neoclassicism of David to the Romanticism of Géricault?

5. How does Théodore Géricault's painting *The Raft of the "Medusa"* (Janson, p. 677, ill. 868) combine heroic drama with a "search for uncompromising truth?"

6. In what ways did Jean-Auguste-Dominique Ingres continue David's Neoclassicism into the 19th century?

7. How are the paintings of Eugène Delacroix exemplary of Neo-Baroque Romanticism?

8. What social commentary is found in the work of Honoré Daumier?

9. Define and describe the printmaking process of lithography (please refer to Janson, p. 674).

10. How is Romantic landscape different from Neoclassical landscape painting?

11. Define the contributions of the following artists and school to Romantic landscape painting:

Camille Corot

Théodore Rousseau

Barbizon School

François Millet

Rosa Bonheur

12. How do the works of John Henry Fuseli express the recesses of the human mind?

Why is Fuseli viewed as a transitional figure from Neoclassicism to Romanticism?

13. What precedents are found in the work of William Blake, and how were they transformed to suit his personal vision?

14. Why was landscape painting such a significant expression of Romanticism?

15. What were the contributions of the following artists to English landscape painting:

John Constable

Joseph Mallord William Turner

John Sell Cotman

How did the contributions of these artists affect the formal qualities of landscape painting?

16. How do the formal techniques of German Romantic painting, as exemplified by Caspar David Friedrich, differ from those utilized by the English painters discussed above?

17. Discuss the different levels of meaning expressed in Philipp Otto Runge's *Morning* (Janson, p. 695, ill. 895).

18. Who were the Nazarenes and what were their goals as artists?

THOMAS COLE. *SCHROON MOUNTAIN, ADIRONDACKS.*
1838. Oil on canvas, 39 3/8 x 63."
The Cleveland Museum of Art. The Hinman B. Hurlbut Collection
(Janson, p. 697, ill. 898)

19. How did the American landscape become a symbol to 19th-century artists in the U.S.?

20. What features of Cole's painting, illustrated above, are exemplary of American Romantic landscape painting?

What was the Hudson River School?

21. What unique interpretation of the landscape is offered by George Caleb Bingham in his work *Fur Traders Descending the Missouri* (Janson, p. 698, ill. 899)?

Sculpture

Janson, pp. 698-706

1. What conditions do we encounter in defining Romantic sculpture?

2. How is the classical orientation of Antonio Canova's figurative sculpture indicative of Romanticism?

3. How would you assess the relationship between Bertel Thorvaldsen's sculpture and ancient Greek art?

4. How do the following sculptors exemplify the themes and the Neo-Baroque style of Romanticism:

 François Rude

 Antoine-Louis Barye

 Auguste Preault

 Jean-Baptiste Carpeaux

5. Discuss the genesis of Auguste Bartholdi's *Statue of Liberty*.

Architecture

1. Why was Romantic revivalism so persistent in architecture in the later 18th and throughout the 19th centuries?

2. Given the complexity of 19th-century architectural styles, the chart below, when completed, will assist our way through the labyrinth of Romantic revivalism.

ARCHITECT	BUILDING	CHARACTERISTICS OF STYLE
Karl Friedrich Schinkel	_____	_____
Horace Walpole	_____	_____
John Nash	_____	_____
Benjamin Latrobe	_____	_____
Sir Charles Barry	_____	_____
A. N. Welly Pugin	_____	_____
Charles Garnier	_____	_____

3. Cite two reasons which promoted the Gothic Revival after 1800 (please refer to Janson, p. 709):

a.

b.

Decorative Arts Janson, p. 712

1. Define Empire style; how was eclecticism a characteristic of this style?

2. How did the Industrial Revolution affect the decorative arts?

Photography Janson, pp. 712-717

1. In what ways do we consider photography an art?

2. What similarities and differences are found between photography and painting?

3. What contributions were made by the following inventor and artists to the history of photography:

Nicéphore Niépce

Louis Jacques Mandé Daguerre

William Henry Fox Talbot

Nadar

4. How are the invention and development of photography uniquely bound to the philosophical character of the 19th century?

5. How did photography respond to the outlook and temperament of Romanticism?

6. How does Timothy O'Sullivan's photograph of *Cañon de Chelle* (Janson, p. 716, ill. 927) break with usual pictorial conventions?

7. Define stereophotography; how did it contribute to a new pictorial vision?

8. Define photojournalism; what photographers and what event in U.S. history encouraged the development of photojournalism?

Chapter Two: Realism and Impressionism

Janson, pp. 718-745

Painting

Janson, pp. 718-734

"The art of painting can consist only in the representation of objects visible and tangible to the painter." With these words, and paintings which rendered everyday reality with emphatic boldness, Gustave Courbet challenged the prevailing art scene. At the time, French Realism was considered revolutionary, but its emphasis on commonplace subject matter influenced the Impressionists, who sought to represent the effects of light, color, and atmosphere in the painting of contemporary life.

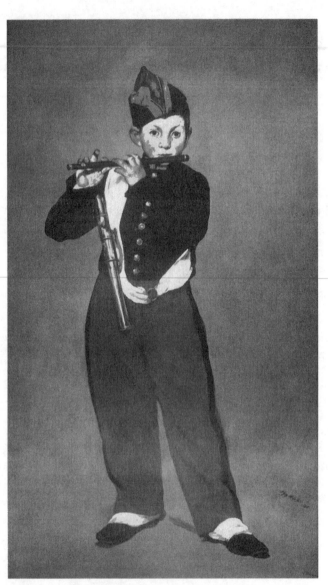

EDOUARD MANET. *THE FIFER.* 1866. Oil on canvas,
63 x 38 1/4." Musée d'Orsay, Paris
(Janson, p. 720, ill. 932)

1. Iconographically, how does this painting by Edouard Manet respond to Courbet's Realism?

2. Explain how the painting addresses the fact that, in Janson's words, p. 720, "brushstrokes and color patches . . . are the artist's primary reality."

3. How does Manet counter traditional methods of illusionism which have been favored in painting since Giotto's time?

4. Discuss the implications of Manet's redefinition of the canvas, not as a "window," but, in Janson's terms, p. 721, as "a screen made up of flat patches of color."

Please return to Janson, p. 718.

5. Discuss the impact of Gustave Courbet's Realism as a reaction to Romanticism.

6. What stylistic influences are apparent in Courbet's paintings?

7. What was Courbet's influence on Manet? (see also question 1)

8. How was the word Impressionism coined to signify the *avant garde* movement in France from 1874 to 1886 (and later with Monet)?

9. What are the artistic (formal) concerns of Impressionism?

10. How would you define the contributions made to Impressionism by the following artists:

Claude Monet

Camille Pissarro

Auguste Renoir

Edouard Manet

Edgar Degas

Berthe Morisot

Mary Cassatt

11. How does a formal tension between "two-D" and "three-D" surface and depth characterize late 19th-century painting?

12. How is English Realism, as exemplified by the paintings of Ford Madox Brown, similar to and distinct from Courbet's Realism?

13. Who were the Pre-Raphaelites and what were their aims as a society of artists?

14. How did James M. Abbott McNeill Whistler advance the concept of Art for Art's Sake through his paintings and writings?

15. What was the American Barbizon School; what was the relation of George Inness to these painters?

16. Describe the contributions of the following artists to Realism in American art:

Winslow Homer

Thomas Eakins

Henry O. Tanner

17. How did Eakins affect the entry of African-Americans and women into the profession of art?

Sculpture Janson, pp. 734-738

1. What innovations are found in the sculptures of Auguste Rodin?

2. How did Rodin make unfinishedness an aesthetic principle of his work?

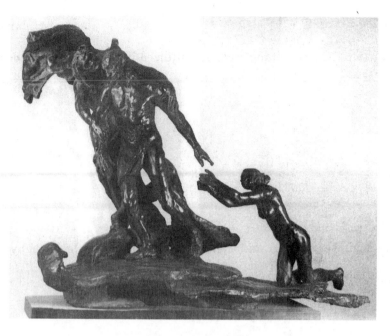

CAMILLE CLAUDEL. *RIPE AGE*. c. 1907. Bronze
34 1/2 x 20 1/2." Musée d'Orsay, Paris
(Janson, p. 737, ill. 958)

3. How is the sculpture of Camille Claudel exemplary of the following attitudes found in late 19th-century sculpture:

Symbolism (see Janson, p. 757)

Realism

autobiographical content

4. In what ways does Edgar Degas's sculpture represent an "uncompromising adherence to unvarnished truth" (Janson, p. 737)?

Architecture Janson, pp. 738-743

1. How is the introduction of new building materials utilized in the architecture designed by:

 Henri Labrouste

 Sir Joseph Paxton

2. What is the relationship between art and engineering in structures designed by:

 John and Washington Roebling

 Gustave Eiffel

Other Fields Janson, pp. 743-745

1. How did William Morris seek to counter the mass production of the machine age?

Describe the formal qualities of Morris's interior environments.

2. What creative innovations did Whistler bring to interior design?

Chapter Three:
Post-Impressionism, Symbolism, and Art Nouveau

Janson, pp. 728-759

Post-Impressionism signifies a variety of styles by artists who went through an Impressionist phase but moved on to diverse artistic endeavors. The experiments of these artists with color, technique, and pictorial structure, along with other art movements in the late 19th century, set the foundation for the radical movements of early 20th-century art. In architecture, new design concepts joined with the use of iron and steel support.

Painting

Janson, pp. 728-746

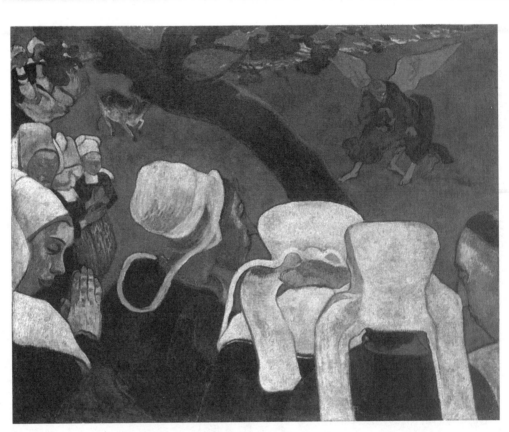

PAUL GAUGUIN. *THE VISION AFTER THE SERMON (JACOB WRESTLING WITH THE ANGEL).* 1888. Oil on canvas, 28 3/4 x 36 1/2."
The National Galleries of Scotland, Edinburgh
(Janson, p. 755, ill. 980)

1. Define Post-Impressionism; how is Paul Gauguin considered a Post-Impressionist artist?

2. How does this painting represent an attempt to resurrect human emotions which, according to the artist, have been neglected due to Western industrialization?

3. In what ways is the style of this painting based on pre-Renaissance sources?

How are the formal concerns evident here related to pictorial developments in the late 19th century?

4. How are the formal and iconographic values exhibited here related to the art movement called Symbolism (or Synthetism)?

5. Who were the Nabis, and how did works like this by Gauguin influence their artistic direction?

178

Please return to Janson, p. 746, as we continue to examine the significant artistic developments of Post-Impressionism.

6. In his quest to uncover, in Janson's words (p. 747), "the permanent qualities beneath the accidents of appearance," cite two ways in which Paul Cézanne altered the formal structure of his paintings:

 a.

 b.

7. How would you describe the pictorial result of Cézanne's analytical approach?

8. Define Neo-Impressionism (also termed, although with some differences, Pointillism or Divisionism).

How do the works of Georges Seurat exemplify this new use and technique of color in painting?

Does the actual practice of Neo-Impressionism fully match its theory?

9. Why did Henri de Toulouse-Lautrec record a decadence of late 19th-century Parisian life?

What other artists were discontented "with the spiritual ills of Western civilization" (Janson, p. 757)?

How was this sentiment a factor in late 19th-century art?

10. How does Vincent van Gogh join intense color with active brushstrokes to communicate an emotional content through his paintings?

11. Describe the formal/iconographic characteristics and contributions of the following Symbolist artists:

Edouard Vuillard

Pierre Puvis de Chavannes

Gustave Moureau

Aubrey Beardsley

Odilon Redon

In what ways was Symbolism both an artistic and a literary movement?

12. How do the works of James Ensor and Edvard Munch communicate a deep penetration of the human psyche?

13. What were the artistic aims of the various Secession movements at the turn of the century?

How does Gustave Klimt's *The Kiss* (Janson, p. 763, ill. 990) exemplify the goals of the Vienna Secession?

14. How would you characterize the mood of Pablo Picasso's Blue Period paintings?

15. How may the German artist Paula Modersohn-Becker be considered both a Symbolist and an Expressionist artist?

Sculpture Janson, pp. 765-768

1. With the influence of Rodin dominant into the opening years of the 20th century, what Symbolist attitudes are expressed in the works of the following sculptors:

Aristide Maillol

Constantin Meunier

George Minne

Wilhelm Lehmbruck

2. How did the influence of pre-industrial Russia affect the sculpture of Ernst Barlach?

1. What was the purpose of *Art Nouveau*, and what was the basis of its formal aesthetic?

2. In what ways does the Casa Mila (Janson, p. 770, ills. 1001-1002), designed by Antoni Gaudi, express the idea of "natural" form?

3. How did the architect Charles Rennie Mackintosh give a new interpretation to the *Art Nouveau* aesthetic in his design for the Glasgow School of Art (Janson, pp. 770-771, ills. 1003-1004)?

4. Henri van de Velde was one of the founders of *Art Nouveau*. In his design for the Theater, Werkbund Exhibition in Cologne (Janson, p. 772, ills. 1005-1006) how does the exterior design relate to the interior spatial units?

How is this building related to the aesthetic of *Art Nouveau*?

5. How did the Marshall Field Wholesale Store, designed by Henry Hobson Richardson (Janson, p. 772, ill. 1007), contribute an unrivaled "strength and dignity" to commercial architecture?

What is the relationship between the structure of the massive walls and the iron skeleton which they conceal?

6. What was the role of Louis Sullivan in the development of the skyscraper?

7. Compare and contrast Sullivan's Wainwright Building (Janson, p. 773, ill. 1009) and his Carson Pirie Scott and Company Department Store (pp. 773-774, ills. 1010-1011).

8. How do these structures follow Sullivan's dictum that "form follows function?"

1. Define photodocumentary; what was the role of Jacob Riis in the development of this form of **artistic and social expression?**

2. How are the photographs of Oscar Rejlander and Henry Peach Robinson an attempt to make **photography a fine art by imitating paintings and prints which enjoyed popular success in Victorian England?**

3. How would you characterize the distinctive style and approach of Julia Margaret Cameron to **photographic portraiture?**

4. How was Peter Henry Emerson's championship of Naturalistic Photography different from yet **similar to the art photography of Robinson (discussed in question 2)?**

5. What was the Linked Ring; how did its members contribute to the development of photography **as an art form?**

6. Discuss the importance of Alfred Stieglitz and Edward Steichen in the promotion of photography in America.

7. The Photo-Secession was an important factor in the growing acceptance of photography as a fine art; what were two formal legacies of this movement which have influenced later photographers:

a.

b.

8. Define the roles of Eadweard Muybridge and Etienne-Jules Marey in the development of motion photography.

Chapter Four:
Twentieth-Century Painting

Janson, pp. 780-843

20th-century art has brought us a variety of artistic experiences unmatched in the history of art. Trends and styles in art are rapidly transformed, as historical, cultural, social, and scientific changes move at an ever more rapid pace. In painting, three trends dominate the century: Expressionism, Abstraction, and Fantasy. But within each of these currents is an array of artistic activities which have enormously broadened and enriched our experience of art.

Painting Before World War I Janson, pp. 780-800

1. What three main international currents have guided painting in the 20th century:

 a.

 b.

 c.

2. Give a short definition of each of these currents:

 a.

 b.

 c.

3. How would you describe the range of approaches found in 20th-century painting?

5. Who were the Fauves and what was their impact on early modern painting?

6. Cite four ways in which Henri Matisse's *The Joy of Life* (Janson, p. 781, ill. 1021) expresses the spirit of Fauvism:

a.

b.

c.

d.

Why is this painting considered revolutionary?

7. What precedents for Matisse's painting are found in Post-Impressionist art?

8. Describe Georges Roualt's contributions to Fauvism.

How were these contributions based in his early training as an artisan?

9. What was *Die Brücke*, and what artists were involved in this group?

10. How is Emil Nolde's *Last Supper* (Janson, p. 784, ill. 1027) different from Leonardo's Renaissance treatment of the same theme (p.455, ill. 596)?

What aspects of Nolde's work particularly associate it with Expressionism?

11. How does Oskar Kokoschka's *Self-Portrait* (Janson, p. 784, ill. 1028) reveal the "inner experiences" of the artist?

WASSILY KANDINSKY. *SKETCH I FOR "COMPOSITION VII."*
1913. India ink, 30 3/4 x 39 3/8."
Collection Felix Klee, Bern
(Janson, p. 786, ill. 1030)

12. What was *Der Blaue Reiter*, and how were its members influenced by Fauvism?

13. In what ways is Kandinsky's painting, illustrated above, considered non-objective?

14. How did Kandinsky develop his non-objective style?

Why was he seeking to communicate a "purely spiritual meaning" in art?

Kandinsky justified his non-objective painting by analogy to what other art form?

15. How did Franz Marc communicate a pantheistic philosophy in his paintings?

16. How is Marsden Hartley's *Portrait of a German Officer* (Janson, p. 788, ill. 1032) an effective work, even without a sitter?

17. Who were the ancestors of 20th-century abstract painting?

18. Why is Pablo Picasso's *Les Demoiselles d'Avignon* (Janson, p.789, ill. 1033) considered formative to "the birth of modern abstraction?"

What diverse stylistic and cultural influences are found in the painting?

19. How would you defend Janson's conclusion, p.790, that *Les Demoiselles d'Avignon* is "a world of its own, analogous to nature but constructed along different principles?"

20. Define Cubism; how would you distinguish between its two phases (especially with regard to picture space)?

PABLO PICASSO. *STILL LIFE WITH CHAIR CANING.* 1912.
Collage of oil, oilcloth, and pasted paper simulating chair caning on canvas,
10 1/2 x 13 3/4." Musée Picasso, Paris
(Janson, p. 792, ill. 1035)

21. How are the two phases of Cubism exemplified in this work?

22. What is a collage, and how do the materials used in a collage both "represent" and "present" themselves simultaneously?

23. Who was Picasso's "partner" in Cubism?

24. Define Orphism; how did the impact of Cubism lead to this non-objective style of painting?

25. How did the Futurists adapt the vocabulary of Cubism to express the "dynamism of modern life" (Janson, p. 794)?

26. Before and immediately following the Russian Revolution in 1917, many Russian artists were counted among the *avant garde*; who were these artists and how were they involved in the following movements:

 Cubo-Futurism

 Suprematism

How were the works of these artists involved in a modern redefinition of time and space?

27. Cite three reasons why Fantasy is a major current in Modern Art:

 a.

 b.

 c.

28. How may the following painters be considered artists of Fantasy:

Georgio de Chirico

Marc Chagall

Marcel Duchamp

29. What was the importance of the Ash Can School to early 20th-century painting in America?

Painting Between The Wars Janson, pp. 800-818

1. By 1920, Picasso was working in two distinct styles; describe these styles:

 a.

 b.

2. How did Picasso achieve a synthesis of these disparate styles in the *Three Dancers* of 1925 (Janson, p. 801, ill. 1049)?

3. How are the formal and iconographic features of Picasso's *Guernica* (Janson, p. 802, ill. 1050) an invective against war?

4. In what ways did the following artists contribute to abstraction and the modern aesthetic between the wars:

Fernand Léger

Charles Demuth

Joseph Stella

Piet Mondrian

Ben Nicholson

5. What was the purpose of *De Stijl*; how did Mondrian's style of Neo-Plasticism fulfill his goal of achieving a "pure reality" in art?

6. What was Dada; how was this movement a reaction to the carnage of World War I?

7. How did Dada's nonsensical approach actually contribute to a liberation of techniques and materials available to artists?

8. Define Surrealism; how was this movement involved with both the literary and visual arts?

9. Define "frottage" and "decalcomania;" how are these processes evident in the work of Max Ernst?

How did the use of these processes allow Ernst to communicate the subconscious by exploiting chance effects?

10. How did Salvador Dali and René Magritte employ representational means to communicate a dream-like state?

11. How are the uniquely personal works of Frida Kahlo related to Surrealism?

12. Define "biomorphic abstraction;" how is this style evident in the paintings of Joan Miro?

13. What influences and concepts lay behind the unique visual expressions of Paul Klee?

14. How did the experience of World War I impact on the following German artists:

Kathe Kollwitz

George Grosz

Max Beckmann

15. How did the American artist Arthur Dove attempt to reveal the "inner life of nature" (Janson, p. 815) through his works?

16. How did Mexican artists of the 1930's use art as a vehicle to promote social justice?

What formal influences affected these artists?

17. Define "The New Objectivity"; how does the work of Otto Dix exemplify this style?

18. How may Georgia O'Keeffe's work be considered both naturalistic and abstract?

19. What factors contributed to conservatism in American art during the 1930's?

20. Although similar in their realist approach, how would you distinguish between these two groups of American artists in the 1930's:

Social Realists

Regionalists

21. How does the work of Edward Hopper transcend the differences of the groups discussed above?

22. What was the Harlem Renaissance; how does Jacob Lawrence invest a "monumentality" in his art?

JACKSON POLLOCK. *AUTUMNAL RHYTHM: NUMBER 30, 1950.*
Oil on canvas, 8'8" x 17'3"
The Metropolitan Museum of Art, New York.
George A. Hearn Fund
(Janson, p. 821, ill. 1079)

1. This painting by Jackson Pollock exemplifies one aspect of Abstract Expressionism, a unique style of painting that developed in New York City in the years following World War II. The two stylistic components of Abstract Expressionism are known as:

 a.

 b.

2. What are the immediate artistic and philosophical roots of Abstract Expressionism?

3. Describe the technique used by Pollock to create this Action Painting.

4. How may Janson conclude, p. 818, that with Action Painting, "painting became a counterpart to life itself?"

5. How is the "primitive realm of the subsconscious" (Janson, p. 819) communicated by the pictographs of Adolph Gottlieb?

6. How does the imagery of Arshile Gorky's paintings transform the biomorphic abstraction of Surrealism and the color intensity of Kandinsky?

7. How did Lee Krasner and Willem de Kooning succeed in joining figurative imagery with the energy of Action Painting?

8. Define *l'art brut*.

What sources influenced Jean Dubuffet in his work?

How does Dubuffet's work relate to his statement (quoted in Janson, p. 823), "I would like people to look at my work as an enterprise for the rehabilitation of scorned values, and . . . a work of ardent celebration."

9. What was the COBRA group?

How did Karel Appel synthesize contemporary European influences with American Action Painting in his work?

10. How does Francis Bacon utilize art historical imagery in his forceful and highly personal expressionist style?

11. What techniques were advanced by Color Field painters?

12. Define the contributions made to Color Field Painting by the following artists:

Mark Rothko

Helen Frankenthaler

Morris Louis

13. Define hard-edge painting.

How does the work of Ellsworth Kelly exemplify this style?

FRANK STELLA. *EMPRESS OF INDIA*. 1965.
Metallic powder in polymer emulsion on shaped canvas, 6' 5" x 18' 8."
Collection, The Museum of Modern Art, New York. Gift of S. I. Newhouse, Jr.
(Janson, p. 828, ill. 1089)

14. How does this hard-edge painting by Frank Stella break from usual pictorial conventions?

In what ways does Stella's composition reinforce an objective reality of the work of art?

15. What three stylistic tendencies have been pursued by African-American artists since World War II:

a.

b.

c.

How are these tendencies manifested in the works of:

Romare Bearden

William T. Williams

Raymond Saunders

16. Define "Op Art;" what are the formal characteristics of this style ?

How is this style reliant on science and technology?

Who are the major practioners of "Op Art?"

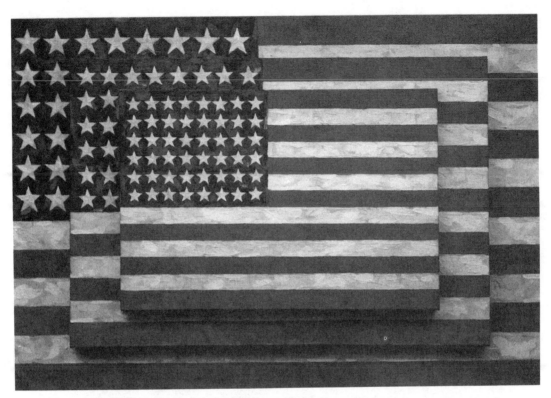

JASPER JOHNS. *THREE FLAGS*. 1958. Encaustic on canvas,
30 7/8 x 45 1/2 x 5."
Collection, Whitney Museum of American Art, New York
(Janson, p. 833, ill. 1096)

17. How is Jasper Johns' painting exemplary of Pop Art?

18. How does Johns stimulate us to think anew about the world of recognizible images which surround us?

19. In what ways did Pop Art respond to the mass commercialization of popular culture in the 1950's and 60's?

20. What aspects of popular culture were utilized in works by the following artists:

Richard Hamilton

Roy Lichtenstein

Andy Warhol

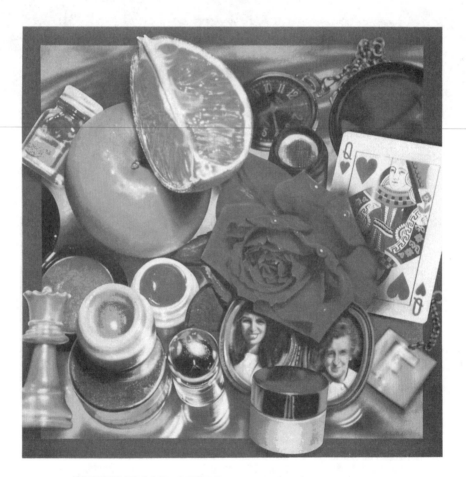

AUDREY FLACK. *QUEEN*. 1975-76. Acrylic on canvas, 6' 8."
Private collection. Courtesy Louis K. Meisel Gallery, New York
(Janson, p. 836, ill.1102)

21. This work by Audrey Flack exemplifies what style of painting?

22. How is this style different from earlier realist styles?

23. How is Flack's painting invested with autobiographical content as well as feminist values?

24. Compare and contrast the preparatory photograph with Don Eddy's completed painting, *New Shoes for H* (Janson, p. 835, ills. 1099-1100).

25. What is the relationship of Neo-Expressionism to Late Modernism?

26. Define *Arte Povera*; how has the movement, and other earlier movements in art, informed the paintings of Francesco Clemente?

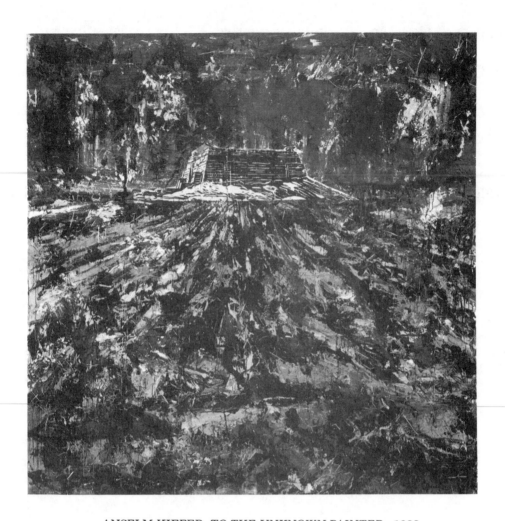

ANSELM KIEFER. *TO THE UNKNOWN PAINTER*. 1983
Oil, emulsion, woodcut, shellac, latex, and straw on canvas. 9' 2" square.
Carnegie Museum of Art, Pittsburgh. Richard M. Scaife Fund
A.W. Mellon Acquisition Endowment Fund.
(Janson, p. 840, ill. 1104)

27. In what ways does Anselm Kiefer's *To the Unknown Painter* exemplify the utilization of previous art styles?

How does the theme of this painting communicate a Late-Modern perspective?

28. Define the contributions made by the following artists in the United States to the varied and vibrant activity of Neo-Expressionism:

Susan Rothenberg

Jennifer Bartlett

Elizabeth Murray

29. Describe how Kay Walkingstick combines Neo-Expressionist and Neo-Abstract values in her work.

Chapter Five:
Twentieth-Century Sculpture

Janson, pp. 844-871

20th-century sculpture has followed, in different ways than painting, the currents of expressionism, abstraction, and fantasy. Modern sculptors have led us to new considerations of form and space, while a tremendous expansion of materials, techniques, scale, and purposes have pushed aside many of our traditional definitions of this art form.

Sculpture Before World War I

Janson, pp. 844-847

1. Analyze the impact of ethnographic art on the sculpture of Henri Matisse.

2. The Rumanian sculptor Constantin Brancusi also was responsive to the early modern rediscovery of ethnographic art. What aspect of ethnographic art appealed to the creativity of Brancusi?

3. How does the expressive abstraction of Brancusi's *The Kiss* (Janson, p. 845, ill. 1110) contrast with the naturalism of Rodin's sculpture (Janson, p. 736, ill. 956) of the same theme?

4. After 1910, how did Brancusi's sculpture in marble or metal differ from his work in wood or stone?

How did Brancusi attempt to communicate an essence, rather than an appearance, in his work?

5. What problems were presented in translating Cubist pictorial ideas into sculpture?

6. In what ways is Raymond Duchamp-Villon's *The Great Horse* (Janson, p. 846, ill. 1113) expressive of the "machine aesthetic?"

7. How were the concerns of Italian Futurism translated into sculptural form?

Sculpture Between the Wars Janson, pp. 847-855

1. Define Constructivism.

How does Vladimir Tatlin's *Project for a Monument to the Third International* (Janson, p. 848, ill. 1115) capture the dynamics of energy, time, and space?

2. What innovation was brought to modern sculpture by Naum Gabo?

3. How do the influences of Cubism and primevalism join forces in the sculpture of Jacques Lipshitz?

4. Define the role of Marcel Duchamp in the creation of "ready-made" sculpture.

How did "ready-mades" expand the material boundaries of sculpture?

5. How did the following artists contribute to Surrealism in sculpture:

Meret Oppenheim

Hans Arp

Picasso

Alberto Giacometti

Julio Gonzalez

6. What important development did Alexander Calder bring to sculpture?

What are the artistic sources for Calder's "mobiles?"

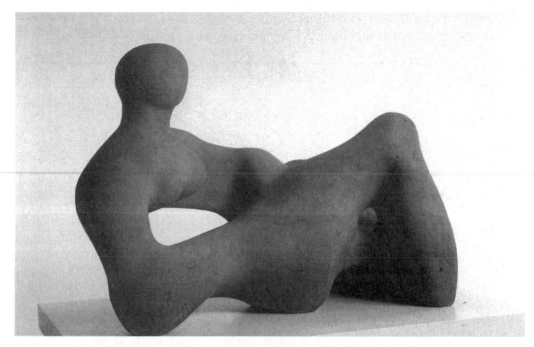

HENRY MOORE. *RECUMBENT FIGURE*. 1938. Green Hornton stone,
length c. 54." The Tate Gallery, London
(Janson, p. 854, ill. 1127)

7. How does Henry Moore's *Recumbent Figure* join the visual forces both of classicism and primevalism?

8. Barbara Hepworth's *Sculpture with Color (Oval Form)* (Janson, p. 854, ill. 1128) synthesizes what three aspects of modern painting and sculpture:

a.

b.

c.

Sculpture Since 1945 Janson, pp. 855-871

1. Define the following concepts found in late modern sculpture:

"Primary Structure"

Minimalism

216

"Environmental Sculpture"

2. How are "Primary Structures" interpreted in the work of the following artists:

Matthias Goeritz

Ronald Bladen

David Smith

Donald Judd

Joel Shapiro

3. How has Minimalism influenced the works of these contemporary African-American artists:

Martin Puryear

Tyrone Michell

Melvin Edwards

4. Describe Claes Oldenberg's imaginative proposals and solutions to public sculpture.

His ideas are in line with what developments in art during the 1950s and '60s?

5. How does the abstract sculpture of Barnett Newman draw an emphathetic response from us?

6. In what ways does the sculpture of Isamu Noguchi mediate Eastern and Western artistic traditions?

7. How did Maya Lin transform the concept of the public monument?

8. How are the works of Robert Smithson and Christo exemplary of "environmental sculpture?"

9. What is the difference between construction and assemblage in sculpture?

In what ways did Robert Rauschenberg pioneer assemblage in the mid-1950's?

LOUISE NEVELSON. *BLACK CHORD*. 1964.
Painted wood, 8' x 10' x 11 1/2." Whitney Museum of American Art.
New York. Gift of Anne and Joel Ehrenkranz.
(Janson, p. 865, ill. 1145)

10. In what ways does Louise Nevelson, through her assemblage sculpture, effect a transfiguration of commonplace objects?

11. How has Chase-Riboud utilized elements of African art to enforce the communicative power of her sculpture?

12. How would you justify Janson's statement (p. 867) that in viewing Eva Hesse's sculpture we see "a central mystery unveiled through its often paradoxical, mythic character"?

13. How may "Environments" and "Installations" be considered unique approaches to art; how are they distinct from traditional definitions of painting or sculpture?

14. How do the following artists contribute to "Environments:"

George Segal

Edward and Nancy Keinholz

The State Hospital, by Edward and Nancy Keinholz, (Janson, p. 868, ill. 1149) is emblematic, in Janson's words, of "the unseen misery beneath the surface of modern life." How does this work communicate this suffering with such an impact on us?

15. In what ways may Judy Pfaff's ebullient "Environments" be compared to the energy of Action Painting?

16. Define Conceptual Art; how is Joseph Kosuth's *One and Three Chairs* (Janson, p. 869, ill.1151) exemplary of Conceptual Art?

What problems are encountered in the evaluation of Conceptual Art?

17. Define Performance Art; how has Joseph Beuys challenged the traditional boundaries of art through his Performances?

Chapter Six:
Twentieth-Century Architecture

Janson, pp. 872-893

The modern aesthetic in architecture involves a variety of factors. The increasing use of steel support systems led architects to "dematerialize" the wall (as seen below), while the "machine aesthetic" affected approaches to design, as it had influenced early modern painting and sculpture. But this approach to show the "essence" of the building, without a profusion of exterior ornamentation, was also tied to the search for social reform. The promise of modern architecture, however, has led to further questions about the suitability of this aesthetic to human needs. The current generation of Post-Modern architects is redefining our experience of architecture in the late 20th century.

WALTER GROPIUS. Shop Block, the Bauhaus,
Dessau, Germany. 1925-26.
(Janson, p. 878, ill. 1167)

1. What was the Bauhaus, and how did it affect the development of architecture and the visual arts in the 20th century?

2. How does Gropius's design reflect the aesthetic, techniques, and materials of modern architecture?

3. What influence did Gropius and the Bauhaus exert on later generations of architects?

Architecture Before World War I Janson, pp. 872-876

Please return to Janson, p. 872, and continue with these questions.

4. What are the essential features of Frank Lloyd Wright's Prairie School houses?

5. Discuss the development of modern architecture in Europe with reference to the following architects:

 Adolf Loos

 Peter Behrens

 Walter Gropius

 Bruno Taut

Max Berg

Antonio Sant'Elia

Architecture Between the Wars Janson, pp. 876-884

1. How is Gerrit Rietveld's Schroder House (Janson, p. 877, ills. 1164-1166) an architectural equivalent of Mondrian's *De Stijl* paintings?

2. Examine the different responses to the International Style by Le Corbusier and Alvar Aalto.

3. How does Expressionist architecture differ from the International Style?

4. How did the presence of Gropius and Ludwig Mies van der Rohe affect the development of architecture in the U.S. following World War II?

5. Define Art Deco; what features distinguish this style of design?

Architecture From 1945 to 1980 Janson, pp. 884-893

1. In what ways do Le Corbusier's later designs contrast with his earlier use of the "machine aesthetic" (see Janson, pp. 879-880; 885)?

2. How does Le Corbusier's design for Notre-Dame-du-Haut at Ronchamp, in Janson's words (p. 885), "mirror the spiritual condition of the modern age"?

3. Discuss the imaginative utilization of reinforced concrete in buildings designed by Eero Saarinen and Pier Luigi Nervi.

4. What is urban planning, and how do architects play an "essential role" in urban revival?

5. How has Late Modernism challenged the International Style?

6. Who are the architects that exemplify Late Modernist approaches to architecture?

What buildings communicate the impact of Late Modernism?

Chapter Seven:
Twentieth-Century Photography

Janson, pp. 894-913

In the 20th century, photography, which earlier had sought to equate itself with art, developed an independent vision. Photojournalists brought home the horrors of war with a new immediacy, while other photographers manipulated processes to achieve abstraction and fantasy in the medium. Artists continue to experiment with uses and processes in the medium, but through all of this photography remains a medium which uniquely shapes our vision of the world.

The First Half Century

Janson, pp. 894-908

1. How did the color print affect the development of photography?

2. What did the following photographers contribute to the "School of Paris:"

 Eugéne Atget

 André Kerstész

 Brassai

 Henri Cartier-Bresson

3. What did Cartier-Bresson mean by "the decisive moment," and how have his work and philosophy had an impact on modern photography?

4. How did Alfred Stieglitz advance photography in the U.S.?

5. What were Stieglitz's "Equivalent" photographs, and how did this concept influence later photographers?

6. How does Edward Weston make us, in Janson's words (p. 899), "see the mundane with new eyes?"

7. How did the following American photographic artists use their medium as an effective means of contemporary communication:

Ansel Adams

Margaret Bourke-White

Edward Steichen

8. Discuss the importance of James Van Der Zee and the Harlem Renaissance.

9. How did the New Objectivity movement in Germany during the late 1920s and early 1930s affect photography?

10. How did the photographs by Robert Capa and Dorothea Lang capture an immediacy of individuals caught in warfare or social and economic conflict?

11. Define photomontage; how did this process affect the current of fantasy in photography?

How is the use of photomontage related to Dada and Surrealism?

12. What is a photogram; photograms may be related to what artistic movements?

13. In what ways did Constructivism affect photography?

Photography Since 1945 Janson, pp. 908-913

1. How would you characterize photography in the first decades following World War II?

2. Discuss the roles of W. Eugene Smith and Robert Frank in documentary photography.

3. How did the following artists contribute aesthetically and technically to the current of fantasy in photography:

Bill Brandt

Jerry Uelsmann

Joanne Leonard

David Woinarowicz

4. As an artist trained in other media, how has David Hockney contributed to recent developments in photography?

Chapter Eight: Post-Modernism

Janson, pp. 914-933

Post-Modernism represents a disavowal of the belief in the value of modernism. In the arts, it is characterized by a pluralistic approach to style, media, and interpretation. Post-Modernism's celebration of diversity makes it difficult to offer a succinct definition of the movement, but it is possible to discuss its primary features.

1. Define Post-Modernism; how does Post-Modernism reflect societal and philosophical currents of our time?

2. Define the following:

 Semiotics

 Deconstruction

Post-Modern Art

Janson, pp. 916

1. In what ways is the definition of post-modern art complex?

2. Discuss the foundation of post-modern art.

3. What is the "Achilles' heel" of Post-Modernism?

Michael Graves. Public Services Building
Portland, Oregon 1980-82
(Janson, p. 917, ill. 1232)

Architecture Janson, pp. 916-922

1. Discuss the Post-Modernist critique of the International style.

2. How is Michael Graves' Public Services Building in Portland (shown above) exemplary of Post-Modernism?

3. What elements of Post-Modernism are found in the architectural designs of:

 SITE Inc.

 James Stirling

4. What principles define Deconstructivism in architecture?

Sculpture Janson, pp. 923-926

1. What attitudes of post-modern art are found in works by:

 Luciano Fabro

 Nam June Paik

 Robert Longo

2. Why is installation art a particularly fertile field for post-modernism?

What artists are exemplary of post-modernism in their installations?

Painting Janson, pp. 927-929

1. What is the relationship of post-modern to late modern painting?

2. Discuss post-modern approaches in paintings by:

 David Salle

 A. R. Penck

 Mark Tansey

Photography Janson, pp. 929-931

1. What is the importance of image and text in post-modern photography?

2. How may we consider the photographic art of Cindy Sherman to be, in Janson's words (p. 931), "a paradigm of post-modernism"?

Postscript: Post-Modern Theory Janson, pp. 931-933

1. Give a brief history of:

Semiotics

Deconstruction

How do these post-modern theories open new avenues of understanding for us?

SELF-REVIEW: THE MODERN WORLD

As you now have become accustomed to these reviews, we shall open our final SELF-REVIEW with three works of art which, most probably, are unknown to you. Following the guide questions for each work, draw your conclusions regarding period, style, formal and iconographic characteristics, and possible artist.

PERIOD: STYLE: POSSIBLE ARTIST:

_____ _____ _____

a. What is the iconography of this image?

Does the intimacy of this theme and visual presentation remind you of the work of any artists which we have studied?

b. What is the formal relationship between the "two-D" and "three-D" qualities of this image?

When were these formal concerns regarding "two-D" and "three-D" elements featured in painting?

c. The works of what artists may have been influential here?

d. What conclusions can you draw from the above analysis?

PERIOD: STYLE: POSSIBLE ARTIST:

_____ _____ _____

a. How does this painting respond to the three main currents of 20th-century art: Expressionism, Abstraction, and Fantasy?

b. How would you describe the abstract elements of this image; are they simple or complex?

c. Can you associate this image with any aspect of the tradition of landscape painting?

d. Which 20th-century American artist was known to combine naturalism with abstraction in her work?

e. Have you any suggestions as to the representational basis of this painting?

3.

PERIOD: STYLE: POSSIBLE ARTIST:

_____ _____ _____

a. The planarity of these figures and objects is a result of what early modern art style?

b. Is the abstraction here more or less severe than that discussed above with the second "unknown" image?

c. How is a sequence of motion established by the composition of the figures?

d. Can you define the social content of this painting?

e. Given the formal planarity, abstraction and content, where would you place this painting in the history of 20th-century art?

Again, we have forty multiple-choice and true/false questions to test your skills in understanding the complexities of art in the modern world.

1. The beginning of the modern world is tied to gradual transitions in political and economic structures.
 a. true
 b. false

2. The paintings of _____ promoted the ideals of the French Revolution.
 a. Cézanne
 b. West
 c. Goya
 d. David

3. American photojournalism developed as photographers covered the _____.
 a. Revolutionary War
 b. Civil War
 c. First World War
 d. industrialization of the U.S.

4. Goya's *The Third of May, 1808*, and Picasso's *Guernica* are alike in that they both _____:
 a. are Romantic works
 b. have Neo-Baroque compositions
 c. stress the reality of the picture surface
 d. are invectives against brutality

5. The French artist who championed Neoclassicism into the 19th century was _____.
 a. Delacroix
 b. Géricault
 c. Ingres
 d. Daumier

6. Le Corbusier's later designs, such as the church at Ronchamp, continue to express the architect's affection for the "machine aesthetic."
 a. true
 b. false

7. Semiotics and Deconstruction are two theories within Post-Modernism.
 a. true
 b. false

8. The photographs of W. Eugene Smith and Robert Frank belong to the modern artistic tradition of fantasy.
 a. true
 b. false

9. The Prairie School houses, which took architecture into its Cubist phase, were designed by _____.
 a. Sullivan
 b. Richardson
 c. Rietveld
 d. Wright

10. The work of Judy Pfaff exemplifies contemporary _____ art.
 a. hard-edge
 b. Environmental
 c. Conceptual
 d. Installation

11. Robert Rauschenberg pioneered assemblage sculpture during Dada.
 a. true
 b. false

12. Action Painting was part of _____.
 a. Surrealism
 b. Dada
 c. Neo-Expressionism
 d. Abstract Expressionism

13. The work of _____ exemplifies Action Painting.
 a. Pollock
 b. Duchamp
 c. Dali
 d. Hopper

14. The paintings of Georgia O'Keeffe are a unique vision of the abstraction in nature.
 a. true
 b. false

15. Mexican mural art of the 1930s was totally non-objective.
 a. true
 b. false

16. The modern art movement which was joined to concepts borrowed from psychoanalysis was _____.
 a. Dada
 b. Cubism
 c. Fauvism
 d. Surrealism

17. The modern art movement which was distinguished by a new liberation of color, as viewed in the paintings of Matisse, was called _____.
 a. Expressionism
 b. Cubism
 c. Dada
 d. Fauvism

18. Michael Graves' Public Services Building in Portland, Oregon, is exemplary of the International Style.
 a. true
 b. false

19. Sculpture represents the greatist creative achievement of Romanticism.
 a. true
 b. false

20. A planographic printmaking process which is based on the principle that water and grease are incompatible is termed _____.
 a. etching
 b. silkscreen
 c. lithography

21. Both Neoclassicism and Romanticism are tied to historicisms in the history of art.
 a. true
 b. false

22. The age of photography was born with the _____.
 a. camera obscura
 b. daguerreotype
 c. stereophotograph
 d. photogram

23. The Post-Impressionist artist who traveled to the South Pacific to rediscover a world of feeling untouched by Western industrialization was _____.
 a. Seurat
 b. Van Gogh
 c. Cézanne
 d. Gauguin

24. The artist who countered Romantic and Academic art in mid 19th-century France with an emphatic realism was _____.
 a. Delacroix
 b. Homer
 c. Courbet
 d. Eakins

25. Henry O. Tanner was among the first African-American artists to achieve an international reputation.
 a. true
 b. false

26. The late 19th-century French sculptor who "broke the mold" of Romantic sculpture with a fresh naturalism and innovative ideas was _____.
 a. Canova
 b. Rude
 c. Carpeaux
 d. Rodin

27. The French artist who redefined the canvas as a screen made up of flat patches of color was _____.
 a. Courbet
 b. Manet
 c. Cézanne
 d. Monet

28. The style of painting concerned with the transient effects of light on objects was _____.
 a. Impressionism
 b. Cubism
 c. Fauvism
 d. Expressionism

29. The American artist who advanced the concept of Art for Art's Sake through his paintings and writings was _____.
 a. Homer
 b. Eakins
 c. Cole
 d. Whistler

30. Mary Cassatt was an American painter who joined the Impressionist group and championed their cause.
 a. true
 b. false

31. Gauguin's Symbolist followers were known as the Pre-Raphaelites.
 a. true
 b. false

32. The Expressionist artist, working in Munich, who turned to a completely non-objective style of painting was _____.
 a. Rouault
 b. Kirchner
 c. Nolde
 d. Kandinsky

33. Picasso's painting _____ was an important work in the formation of modern abstraction.
 a. *Guernica*
 b. *Les Demoiselles d'Avignon*
 c. *Mother and Child*
 d. *Three Musicians*

34. The Russian avant garde style of the early 20th century which sought to express a "supreme" reality was called _____.
 a. Cubo-Futurism
 b. Futurism
 c. Suprematism
 d. Synthetic Cubism

35. The art movement that preached nonsense and anti-art in reaction to the carnage of World War I was called _____.
 a. Dada
 b. Cubism
 c. Surrealism
 d. Expressionism

36. Futurism was an Italian art movement, influenced by Cubism, which proposed to address the dynamism of modern life in art.
 a. true
 b. false

37. The artist who explored chance effects with "frottage" and "decalcomania" was _____.
 a. Arp
 b. Duchamp
 c. Ernst
 d. Dali

38. Miro's approach to Surrealism has been termed "biomorphic abstraction."
 a. true
 b. false

39. Helen Frankenthaler's work is exemplary of Color Field Painting.
 a. true
 b. false

40. The art movement which was built on popular, commercial imagery of the 1950s and 1960s is known as _____.
 a. Op Art
 b. Photorealism
 c. Neo-Expressionism
 d. Pop Art

Discussion Questions:

1. In what ways do the roots of Early Modern Art extend back into the fertile environment of the 19th century?

2. How has the "secularization" of the Modern World affected developments in the visual arts?

3. How is Post-Modernism different from past historicisms in the history of art?

4. Given the radical departure of Modern Art from artistic traditions, how has the definition of artist and audience changed in our time?

5. How has the concept of "objectivity" affected many aspects of 20th-century art?

6. How do the primary sources for Part Four reinforce our understanding of the diverse, quickly changing, and innovative movements of art in the Modern World?

ANSWER KEY

SELF-REVIEW: THE ANCIENT WORLD

1. The man and woman portrayed in this high relief sculpture are presented in a representational style. We can detect particular features of physiognomy on their sober and determined faces, and the drapery falls in a naturalistic manner. We have experienced this type of realistic portrayal of the human figure in Hellenistic and Roman art, especially Roman Republican art. The figures are similar to the late 1st century B.C. sculpture of *A ROMAN PATRICIAN WITH BUSTS OF HIS ANCESTORS* (Janson, p. 190, ill. 263). The Roman interest in history and in devotion to the family lend further evidence to this object as dating from the Roman Republican period. It is a grave relief of a husband and wife dating from the 1st century B.C.

1. c 2. c 3. d 4. a 5. c 6. d 7. a 8. b 9. d 10. b 11. a 12. d 13. b 14. c 15. b 16. d 17. c 18. a 19. b 20. b 21. a 22. d 23. b 24. a 25. d 26. a 27. d 28. a 29. c 30. a 31. c 32. b 33. a 34. b 35. d 36. b 37. a 38. a 39. a 40. b

SELF-REVIEW: THE MIDDLE AGES

1. The strong black lines which separate areas of color inform us that this is a stained glass window. The use of stained glass and the formal, almost iconic, central image of the Virgin Mary and Christ Child suggest a date in the later Middle Ages, during the Gothic period. Stained glass windows were part of the artistic vocabulary of Gothic churches, and the cathedral at Chartres is especially known for its stained glass windows. This is a particularly significant window, for the central portion, dating from the 12th century, was rescued from a fire at Chartres cathedral in 1194. The side panels depicting angels were then added in the mature Gothic style of the 13th century. Can you discuss the formal differences between the central figures and those which flank it? How are these differences related to the development of late Medieval painting?

1. c 2. d 3. c 4. a 5. d 6. c 7. b 8. c 9. b 10. a 11. a 12. d 13. c 14. a 15. d 16. c 17. d 18. a 19. b 20. c 21. c 22. a 23. a 24. b 25. d 26. c 27. a 28. d 29. a 30. a 31. c 32. c 33. a 34. b 35. a 36. c 37. a 38. d 39. b 40. c

SELF-REVIEW; THE RENAISSANCE THROUGH THE ROCOCO

1. Both of our "unknown" works in this SELF-REVIEW are by women artists. Our first work is an example of genre painting, capturing a sensitivity to everyday events. The naturalism of the scene, the composition's lively, momentary effect, and the intense *chiaroscuro* recall Dutch Baroque painting, especially the work of Frans Hals (see Janson, p. 581). The painting is by Judith Leyster and it is titled *GAY CAVALIERS* (it is also known as *THE LAST DROP*); it dates from c. 1628-9. Leyster (see Janson, p. 582) was a successful teacher and artist in Holland during the Baroque period. As Janson notes, she sacrificed something of her artistic career after she bore three children.

2. Our second "unknown" painting is a still life, a meticulous rendering of objects, here set within dramatic lighting. The realism of still life painting is in many ways democratic, for it appeals to many without the need for an academic education in the visual arts. Still life painting, with its insistent naturalism, was popular during the Baroque period, especially as part of the new art market in the Netherlands. The inclusion of the skull adds a moral message to the work, reminding us that the enjoyment of earthly pleasures will pass. Our artist, Maria van Oosterwyck, was respected throughout Europe in the mid-17th century as a still life artist.

1. a 2. d 3. d 4. a. 5. b 6. b 7. c 8. b 9. c 10. c 11. d 12. c 13. a & d 14. d 15. b 16. d 17. a 18. a 19. d 20. b 21. b 22. a 23. a 24. d 25. a 26. d 27. a 28. b 29. d 30. d 31. b 32. c 33. a 34. d 35. b 36. a 37. c 38. a 39. a 40. b

SELF-REVIEW; THE MODERN WORLD

1. The iconography of this image, a theme centering on women, along with formal qualities which reflect attitudes of the late 19th century in painting, suggest Mary Cassatt as the artist (see Janson, pp. 726-727). From the influence of Oriental prints and the formal concerns reflected in Manet's paintings, *avant garde* artists of the late 19th century expressed the formal tensions between the pictorial surface and the tradition of illusory space in many of their works. Here, the sharply oblique floor plane recalls the paintings of Degas; as the effects of patterns push toward the picture surface while the overlapping and slight diminution of size of the woman's reflection create a spatial presence. This print, which is titled *COIFFURE* and dates from 1891, exemplifies Mary Cassatt's understanding of the advances made in French painting from Manet through the Impressionists.

2. Now this one might be difficult! The gradation of colors (which, in this black and white reproduction, appear as values) from the circular shape in the upper left area, through concentric rings, suggest a rhythmic, pulsating effect. The darker, horizontal shape below carries the suggestion of a landscape. The painting is abstract, and dates from the 20th century. The abstraction is simple and direct, and the landscape/sky association is tied to the observation of nature. Are you ready? The painting is one of a series of watercolors by Georgia O'Keeffe from 1917 (see Janson, p. 817). This one is titled *EVENING STAR III*, and it was inspired by viewing the evening star at sunset.

3. The planarity of the figures and background, as well as the expressive distortion of shapes, relates this work to both the currents of abstraction, especially Synthetic Cubism, and expressionism in 20th-century art. The sequential movement of the figures from left to right reinforces the compelling drama of the theme, while the fact that they are black people caught in what we interpret as a most anxious moment suggests a social purpose and communication to the image. The artist, Jacob Lawrence is a contemporary African-American painter whose works often address the struggle and dignity of Black people (see Janson, p. 818). This painting is titled *FORWARD* and dates from 1967.

1. b 2. d 3. b 4. d 5. c 6. b 7. a 8. b 9. d 10. d 11. b 12. d 13. a 14. a 15. b 16. d 17. d 18. b 19. b 20. c 21. a 22. b 23. d 24. c 25. a 26. d 27. b 28. a 29. d 30. a 31. b 32. d 33. b 34. c 35. a 36. a 37. c 38. a 39. a 40. d

Additional Notes

Additional Notes

Additional Notes

Additional Notes